FAMILY TREE SHOWING THE CONNECTIONS BETWEEN THE BRITISH, DANIS

1840
Queen Victoria = Albert of Saxe-
(1819–1901) Coburg and Gotha
 (1819–1861)

1842
King Christian IX = Louise of Hesse-Cassel
of Denmark (1817–1898)
(1818–1906)

Alexan
Tsar of
(1818

3s, 4d

1858
Victoria, = Frederick III
Princess Royal Emperor of
(1840–1901) Germany (1831–1888)

3s, 1d
Dagmar (Tsarina Maria = Alexander III
Feodorovna) (1847–1928) Tsar of Russia
 (1845–1894)

1884
Grand Duke = Elizabeth of Hesse
Sergei (1864–1918)
(1857–1905)

2s, 1d

1863
King Edward VII = Alexandra of
(1841–1910) Denmark
 (Queen Alexandra)
 (1844–1925)

1874
Marie = Alfred, Duke of Edinburgh
(1853–1920) and Duke of Saxe-Coburg
 and Gotha
 (1844–1900)

Albert Victor,
Duke of Clarence and
Avondale (1864–1892)

1889
Louise, = 1st Duke of Fife
Princess Royal (1849–1912)
(1867–1931)

1896
Maud = Charles of Denmark
(1869–1938) (King Haakon VII
 of Norway)
 (1872–1957)

1894
Xenia = Grand Duke
(1875–1960) Alexander
 of Russia
 (1866–1933)

1s, 1d

Victoria (1868–1935)

1893
King George V = Mary of Teck
(1865–1936) (Queen Mary)
 (1867–1953)

1894
Nicholas II = Alix of Hesse
Tsar of Russia (Tsarina Alexandra
(1868–1918) Feodorovna)
 (1872–1918)

1911
Grand Duke = Natalia
Michael Cheremetevski
(1878–1918) (1880–1952)

King Edward VIII
(1894–1972)

Henry, Duke of Gloucester
(1900–1974)

Olga
(1895–1918)

Tatiana
(1897–1918)

Maria
(1899–1918)

Anastasia
(1901–1918)

Alexis
(1904–1918)

1923
King George VI = Lady Elizabeth Bowes-
(1895–1952) Lyon (Queen Elizabeth,
 The Queen Mother)
 (1900–2002)

1947
Queen Elizabeth II = Philip, Duke of
(b.1926) Edinburgh (b.1921)

Princess Margaret Rose,
Countess of Snowdon
(1930–2002)

Charles, Prince of Wales 2s, 1d
(b.1948)

Royal Fabergé

Caroline de Guitaut

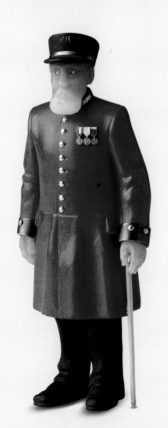

Royal Collection Publications

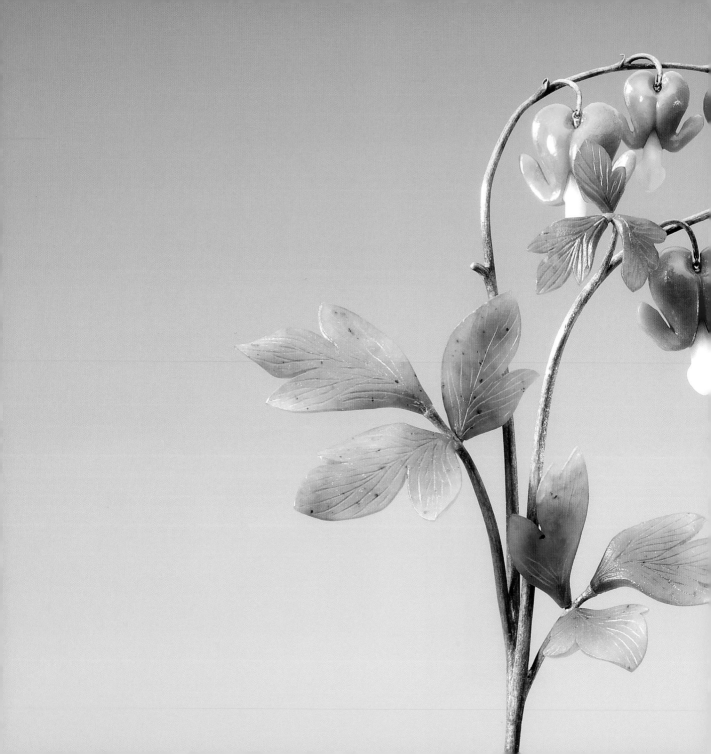

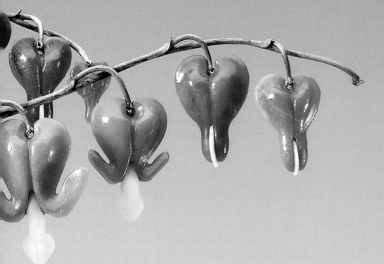

CONTENTS

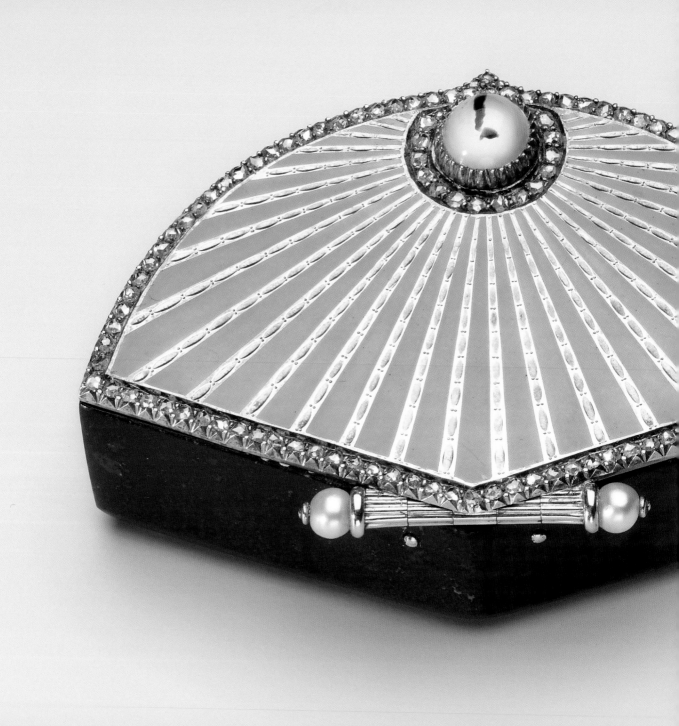

INTRODUCTION

THIS BOOK provides a unique insight into the acquisitions of six generations of the British royal family from the 1870s to the present day and charts the formation of the most significant collection of works by the firm of Fabergé ever to have been formed. From the reign of Queen Victoria to Queen Elizabeth II, members of the royal family have shared an enduring enthusiasm for and enjoyment of Fabergé's creations. The majority of pieces exchanged between them were given as birthday or Christmas presents, whether acquired in Russia or, after 1903, from the branch of the firm established in London. Some were specially created by Fabergé to mark significant anniversaries or special occasions and others incorporate portraits of people, places and even animals of importance to the royal family, whether in the form of decorative frames, elegant boxes or hardstone portrait models. The wider dynastic links of the British royal family with their Russian and Danish cousins are also encompassed, with many pieces having been purchased from Fabergé's headquarters in St Petersburg by the last two tsars of Russia and their families, and sent as gifts to England. The resulting collection is the largest and most diverse in existence, intimately associated with the lives of successive monarchs and their consorts. Included are some of the most important pieces from the collection, each one telling a story of unique family provenance, and attesting to the unending fascination for Fabergé's perfect craftsmanship.

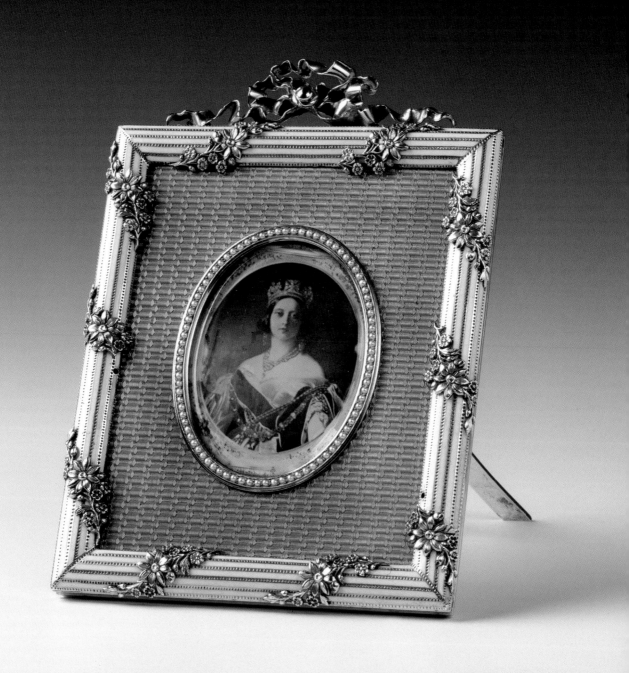

Queen Victoria

1819–1901

QUEEN VICTORIA was the first reigning British monarch to make purchases from the Russian goldsmith and jeweller Peter Carl Fabergé (1846–1920), thereby starting an interest and enthusiasm for the work of the firm of Fabergé in the Royal Family that continues today, five generations and more than one hundred years later.

In 1895 a reference in Queen Victoria's ledger refers to a payment to K. Faberger [sic] of £20 9s 6d for 'a sapphire and rose pin'.[1] In 1897 the Queen's account for presents records a payment to 'C. Fabergé' for 'brooches etc', possibly ordered in connection with the celebrations for her Diamond Jubilee. In July 1898 a further payment was made to the firm for jewellery.[2] In the same year Queen Victoria purchased a Fabergé gold and nephrite photograph frame which was given to Queen Louise of Denmark, the mother of her daughter-in-law, Alexandra, Princess of Wales.

In the 1890s the Queen had been the recipient of gifts made by Fabergé from one of her favourite granddaughters, Alix of Hesse, who married Tsar Nicholas II of Russia in 1894, becoming Tsarina Alexandra Feodorovna. A notebook cover was sent to the Queen for Christmas 1896 and the Tsarina also presented her with a Fabergé clock.

The dynastic marriages of Queen Victoria's generation and that of her children meant that virtually all the reigning monarchs of Europe at the end of the nineteenth and turn of the twentieth century were closely related to one another. Family gatherings in Germany, Denmark, Russia and England were commonplace and gifts were always exchanged on such occasions. Having been appointed a supplier to the imperial court of Tsar Alexander III (the father of Nicholas II) in 1885, and with a flair for combining exquisite design and technical virtuosity and applying them to a vast range of desirable products, Fabergé soon became established as the premier supplier of gifts that had a universal appeal.

Queen Victoria's children were to become passionately interested in Fabergé's work. Princess Beatrice, her youngest daughter, made several purchases from the firm, but it was the Queen's heir, Edward, Prince of Wales and his wife, Princess Alexandra, who were to become the leading collectors of the next generation.

Left: Laurits Regner Tuxen (1853–1927), *The Family of Queen Victoria in 1887*, 1887. RCIN 400500

Notebook case
Acquired 1896

On 22 June 1897 Queen Victoria celebrated her Diamond Jubilee. The official commemoration took place in London with a service of thanksgiving conducted outside St Paul's Cathedral, as the Queen walked with difficulty and could not mount the steps to go inside. A dinner was held the night before at Buckingham Palace, an occasion which Queen Victoria recalls in her Journal: 'The dinner was in the Supper Room ... All the family, foreign Royalties, special Ambassadors & Envoys were invited. I sat between the Arch Duke Franz Ferdinand & the Pce of Naples.'[3] The Queen chose to record the attendance of her guests for the Diamond Jubilee celebrations in this notebook enclosed in a Fabergé case which also bears her signature and the date. The pages of the notebook are thus signed by the crowned heads of Europe who attended. Its cover is luxuriously

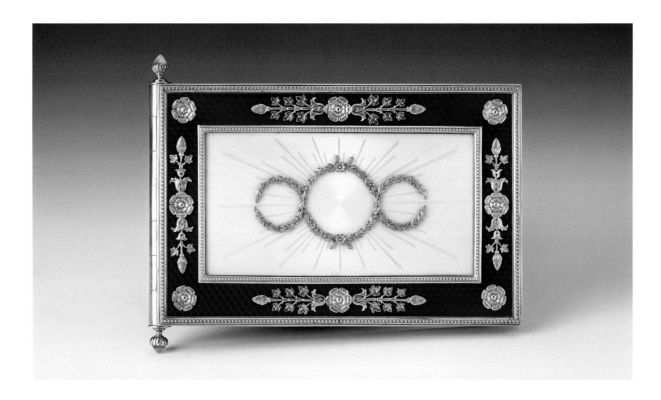

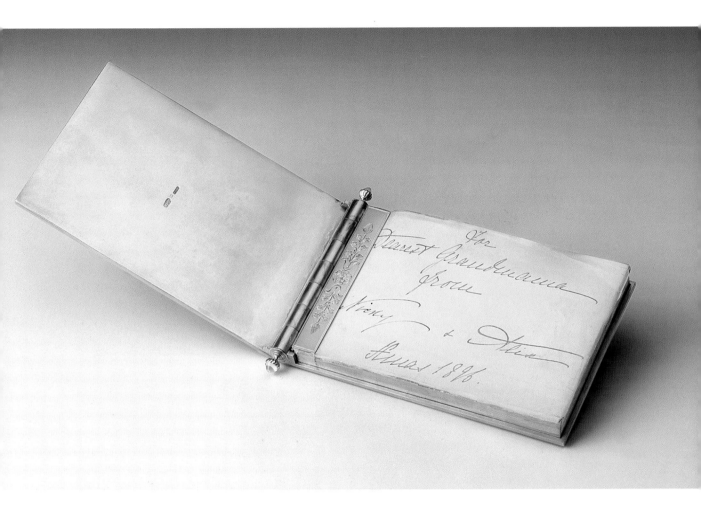

embellished, the silver-gilt richly engine-turned with geometric and sunburst patterns and enamelled in red and oyster – an outstanding example of Fabergé's famous revival of guilloché enamelling, to which laurel wreaths, stylised flowers and foliage in silver-gilt are applied. The pencil concealed in the hinge is set with cabochon moonstones at either end. The case was a Christmas present to the Queen from Tsar Nicholas II and his wife, Alexandra Feodorovna,

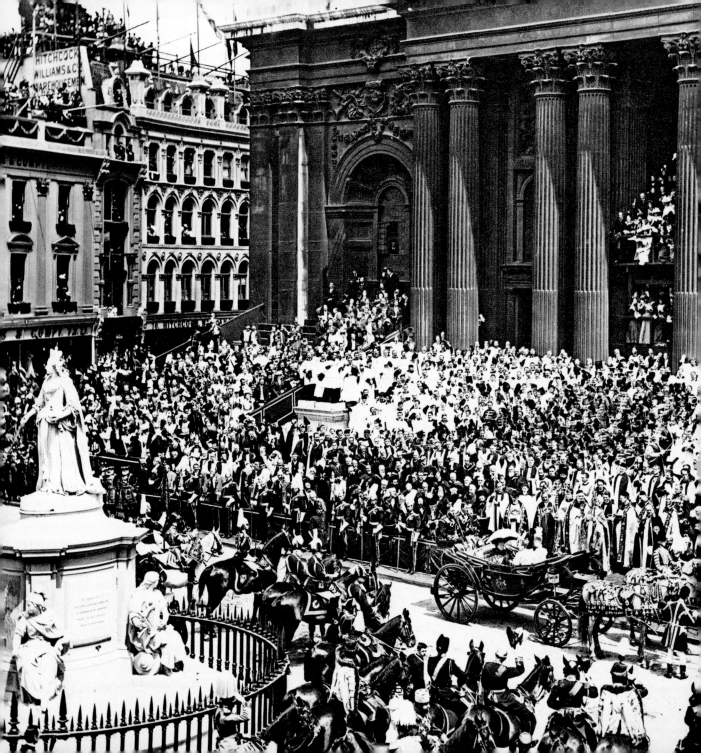

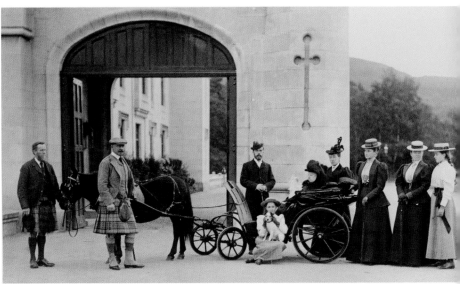

who purchased it jointly in St Petersburg in December 1896 at a cost of 250 roubles. The couple had stayed with Queen Victoria at Balmoral in Scotland earlier in the same year, from 22 September to 3 October. The Queen wrote fondly of the visit; 'It seems quite like a dream having dear Alicky & Nicky here.'[4] During the visit the Tsarina showed Queen Victoria some of her jewels, many of which were supplied by Fabergé: 'Alix showed me her beautiful jewels, of which she has quantities, all her own private property.'[5]

Above: Queen Victoria with Tsar Nicholas II, Tsarina Alexandra Feodorovna and other family members, Balmoral, 1896. RCIN 2160230

Left: Queen Victoria's Diamond Jubilee service outside St Paul's Cathedral, 1897. RCIN 2109683

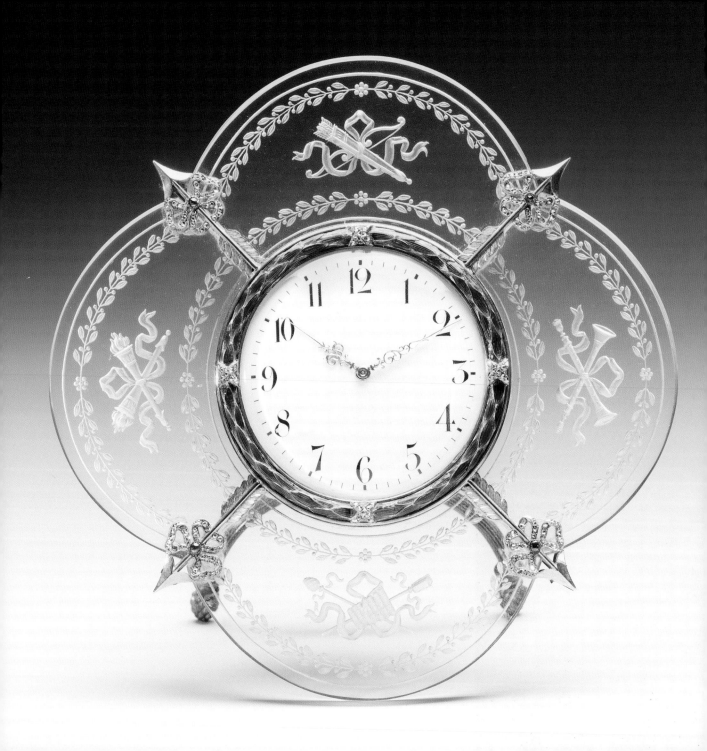

Desk clock
Acquired *c.*1900

This unusual rock crystal desk clock was presented to Queen Victoria by her granddaughter Tsarina Alexandra Feodorovna around 1900. On receipt of the news of the death of Tsar Alexander III, on 1 November 1894, the Queen wrote of the new Tsar and Tsarina in her journal: 'What a terrible load of responsibility & anxiety has been laid upon the poor Children! I had hoped and trusted they would have many years of comparative quiet & happiness before ascending this thorny throne'.[6] The majority of Fabergé's clocks are in the form of gold strut clocks, enamelled in a wide variety of colours and set with gemstones in gold. This clock of rock crystal is engraved with trophies incorporating torches and a quiver as well as musical attributes. The rock crystal panels are divided by four gold arrows set with rubies and diamonds. The white enamel dial is surrounded by a bezel of green enamelled laurel with diamond-set ribbon ties. Following Queen Victoria's death, the clock was used by King George V; he kept it on his desk at Buckingham Palace.

Tsar Nicholas II and Tsarina Alexandra Feodorovna, Balmoral, 1896.
RCIN 2802369

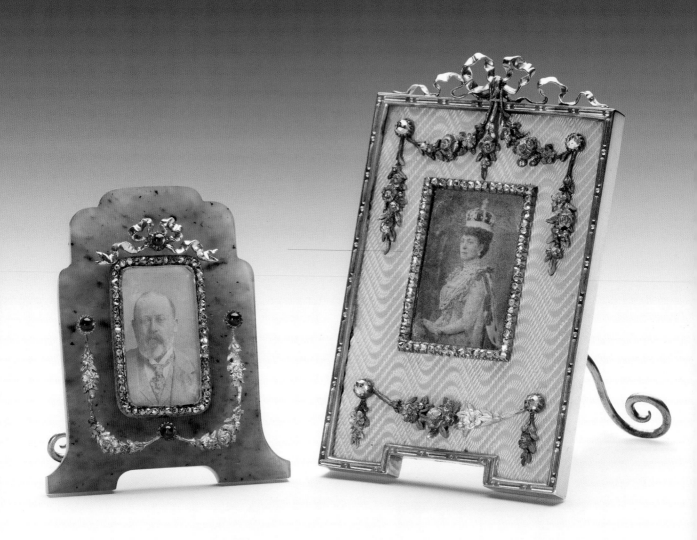

King Edward VII and Queen Alexandra

1841–1910 and 1844–1925

K ING EDWARD VII was an enthusiastic patron of Fabergé. From the 1870s until his death in 1910, he purchased a large number of pieces from the firm – some from its St Petersburg headquarters during visits to Russia, but most from the branch established in London in 1903. The King's reign coincided with the most prolific and successful period in the firm's history. The London branch which, thanks to the patronage of the King and the royal family, attracted the elite of Edwardian society, sold over 10,000 objects in the period between 1903 and 1915.

The King visited the London branch in person and in addition pieces were often sent to Buckingham Palace on approval, usually delivered by Henry Bainbridge, the branch manager from 1907 to 1915. King Edward VII had a particular liking for the fashionable and elegant cigarette cases produced by the firm and was given many examples, notably the blue enamelled case with a diamond snake (p. 23). Fabergé's hardstone animal carvings were of great interest to the King. In 1907 he placed a direct commission with the firm, asking Fabergé to produce portrait models of the horses and dogs kept on his estate at Sandringham. The animals were to be a birthday present to Queen Alexandra, who had begun to form a collection of them. In the event the King was so delighted with the result that the commission was dramatically extended and took several years to fulfil. As a result the group of animals formed by the King and Queen became the most significant collection of Fabergé's animals in existence.

Queen Alexandra, the daughter of King Christian IX of Denmark, was the most important influence on the formation of the royal collection of Fabergé. She was introduced to the goldsmith's work by her sister, Dagmar, who became Tsarina Maria Feodorovna on her marriage to Tsar Alexander III in 1866. During the same year, Carl Fabergé's father Gustav had begun to supply the imperial cabinet. The sisters shared an admiration for Fabergé creations. During the visit of the Prince and Princess of Wales and the Duke of York (later King George V) to attend the funeral of Alexander III and the marriage

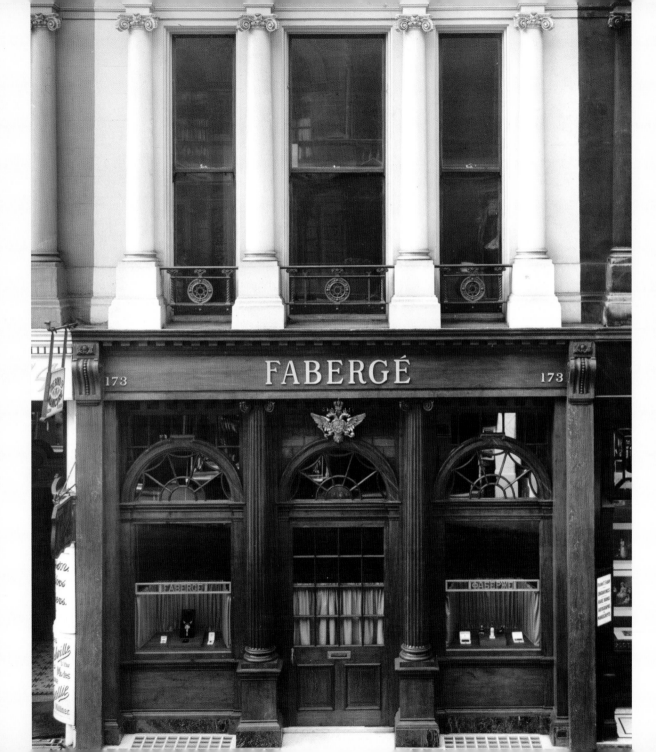

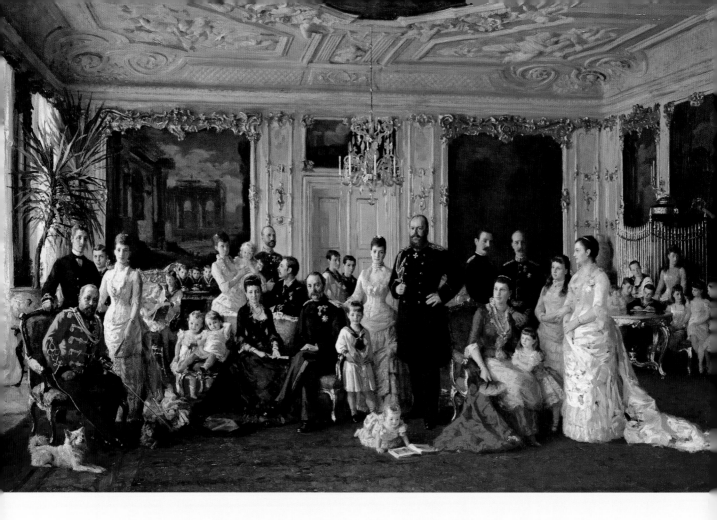

Laurits Regner Tuxen (1853–1927),
*The Family of King Christian IX and
Queen Louise of Denmark, 1885*, 1885.
RCIN 402341

of Tsar Nicholas II in 1894, the Princess's birthday (1 December) was spent at the Anichkov Palace, her sister's residence in St Petersburg. Both the Prince of Wales and the Duke of York had paid several visits to Fabergé's premises in Bolshaya Morskaya street prior to 1 December. When the Duke of York saw his mother's birthday presents he recorded in his diary 'Motherdear's birthday … saw all the presents, she has got half Fabergé's shop.'[7] Works by Fabergé were regularly sent to Queen Alexandra by her sister and the Tsar at Christmas, a tradition continued

by Tsar Nicholas II. On 29 December 1905, Queen Alexandra wrote from Sandringham to her son, the Prince of Wales, 'In Russia alas things are very bad still … in Moscow & in the Provinces the state of things are too awful for words – dear Nicky & Alicky sent us Xmas presents in spite of all by a messenger …'[8]

Bainbridge explains in his 1949 biography of Carl Fabergé that Queen Alexandra was most interested in the animals and flowers, and she did indeed form very significant collections of both. However, the Queen acquired examples of virtually every type of object that the firm produced, from fans to desk clocks and snuffboxes to parasol handles.

Frames and boxes with enamelled views of different royal residences were acquired by the King and Queen, and many objects were undoubtedly designed specially for Queen Alexandra, often with the King in mind. During their reign, the works they acquired began to be recognised as a distinctive collection and were specially displayed in cabinets in the Drawing Room at Sandringham House.

The desirability of Fabergé objects combined with overt royal patronage brought customers flocking to the firm – many of them from the King and Queen's circle of friends, who purchased pieces for the royal couple. They included the Marquis de Soveral (the Portuguese Minister in London), Leopold de Rothschild, Sir Ernest Cassel and Lord Revelstoke; and also Stanislas Poklewski-Koziell, councillor at the Russian embassy, who gave the Queen a magnificent flower (p. 54). The ledgers of the London branch (which survive in part), are full of the names of royal and aristocratic clients from every corner of Europe and the Indian sub-continent.

Above all, the King and Queen influenced the next generation of royal Fabergé collectors: King George V and Queen Mary. They became regular customers of the London branch and were later, after the revolution in Russia, to acquire significant pieces formerly in the possession of the imperial family.

Fortieth Anniversary
cigarette case
Acquired 1903

This sumptuous cigarette case
was given to King Edward VII
as a fortieth wedding anniversary
present by his sister-in-law,
the Dowager Tsarina Maria
Feodorovna on 10 March 1903.
Its elegant rounded rectangular
shape is composed of red, yellow
and white gold, a typical technique
of Fabergé's work, in a sunburst
design centring on the combined
cipher of Edward and Alexandra
and on the reverse the date,
10 March 1903 XL 1863–1903,
all set in diamonds.

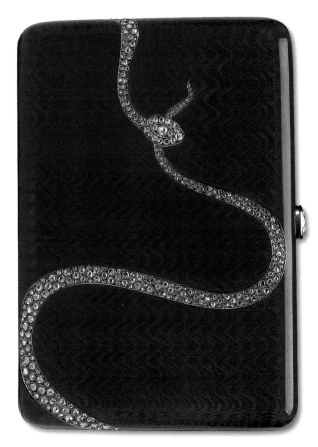

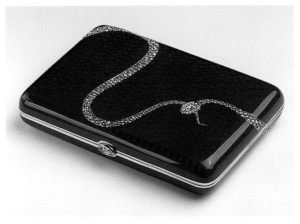

Cigarette case
Acquired 1908

This elegant cigarette case has a provenance unique in the history of the royal collection of Fabergé, having left the collection in 1911 only to be returned over twenty years later. The case represents one of Fabergé's greatest expressions of the Art Nouveau style, with its sinuous diamond-set snake entwined around the front and back of the box. The moiré guilloché enamel is in one of Fabergé's most exceptional colours. But the design is not purely decorative; the snake biting its tail is a symbol of unbroken and everlasting love and thus it is not surprising to learn that the case was given to King Edward VII by his favourite mistress, Mrs George Keppel, in 1908. Perhaps recognising the significance of the gift, Queen Alexandra returned it to Mrs Keppel as a memento following the King's death in 1910. Twenty-five years later, in 1936, Mrs Keppel gave the case to Queen Mary, thereby ensuring that it would remain in royal ownership.

Box with a view of the Houses of Parliament
Acquired 1908

Fabergé continued the vogue, started in the eighteenth century, for snuffboxes decorated with topographical views, buildings and monuments. Several with Russian views were produced – for example numerous boxes featuring Falconet's monument to Peter the Great (see p. 89) and the Kremlin (p. 82), as well as views of private residences. Once the London branch of the firm had been established in 1903, the demand for such boxes was extended by Fabergé's English clientele. According to Bainbridge, boxes and frames with views of the royal residences 'would be enough to keep Fabergé going until the end of King Edward's reign and well into King George's.'[9] This nephrite box, set with a sepia enamelled view of the Houses of Parliament in gold mounts, was purchased by Grand Duke Michael of Russia from Fabergé's London branch in November 1908 for £160 and was presumably given to King Edward VII.

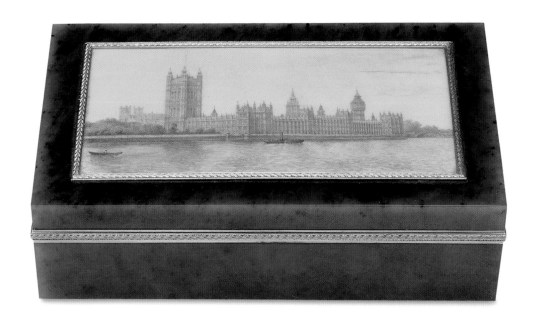

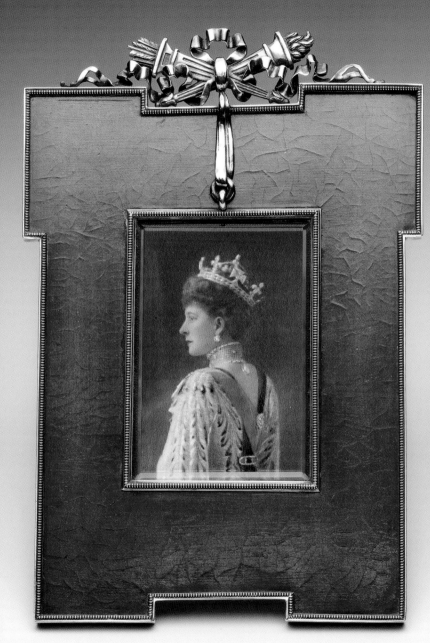

Frame with a photograph
of Queen Alexandra
Acquired *c.*1900

This frame is unusual, lacquer being
a relatively rare technique in Fabergé's
oeuvre. It was produced in the
workshop of Anders Nevalainen, who
specialised in frames and enamelled
objects. The coloured photograph by
W&D Downey dates from 1913.

Frame with a photograph of Persimmon
Acquired *c.*1908

Enamelled in the racing colours of King Edward VII, this frame contains a photograph of the King's most successful racehorse, Persimmon. The horse was also immortalised in Fabergé's silver model (p. 36), included by the King in the Sandringham commission of 1907 for which the horses, dogs and other animals found on the estate were modelled from life and carved in a selection of hardstones. The idea of personalising the colours of frames and other objects was taken up by Leopold de Rothschild who, like the King, had a portrait of his racehorse St Frusquin modelled in silver.

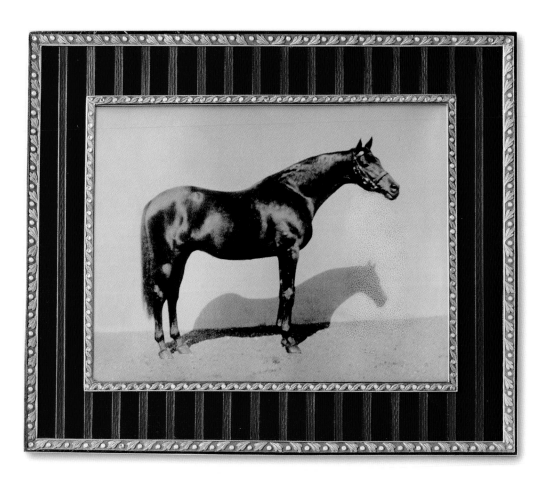

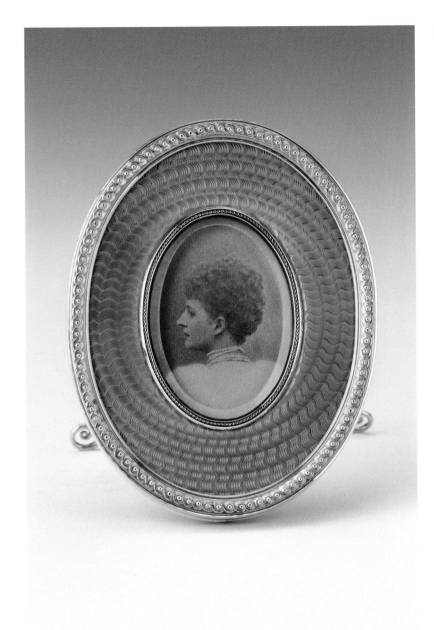

Frame with a photograph of Queen Alexandra when Princess of Wales
Acquired *c*.1896

Made in the workshop of Fabergé's head workmaster, Michael Perchin, this oval gold frame with bright orange guilloché enamel contains a photograph of Queen Alexandra when Princess of Wales, dating from 1898 and taken by Alice Hughes. The frame was likely to have been a gift from Russia from the Queen's sister, as the London branch was not open at this date.

Frame with a photograph of Tsar Alexander III
Acquired c.1896

This frame was made in Fabergé's Moscow workshops a few years after the death of the Tsar in 1894. The photograph shows him in the uniform of a Cossack General. Grand Duke Alexander had become Tsarevich after the death of his older brother Nicholas in 1865 and on 28 October 1866 he married his late brother's fiancée, Princess Dagmar of Denmark. He became Emperor in 1881 after the assassination of his father. The Tsar died at the age of 49 and his funeral took place on 19 November. It was attended by the Prince and Princess of Wales (later King Edward VII and Queen Alexandra) and by the Duke of York (later King George V), who recalled the Tsar's funeral in his diary: 'The funeral of darling uncle Sacha took place in the fortress Church of St Peter & St Paul, the Service began at 10.30 & lasted till 1.00 … It was all terribly sad & most impressive & I shall never forget it … Darling aunt Minny was so brave & behaved so beautifully.'[10] The frame is thought to have been a gift from Tsarina Maria Feodorovna to her sister, Queen Alexandra.

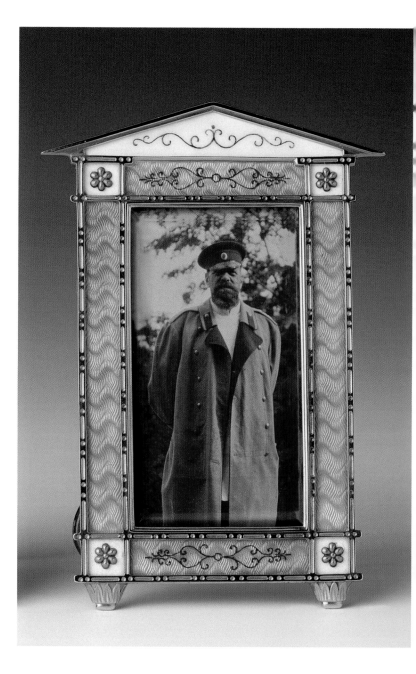

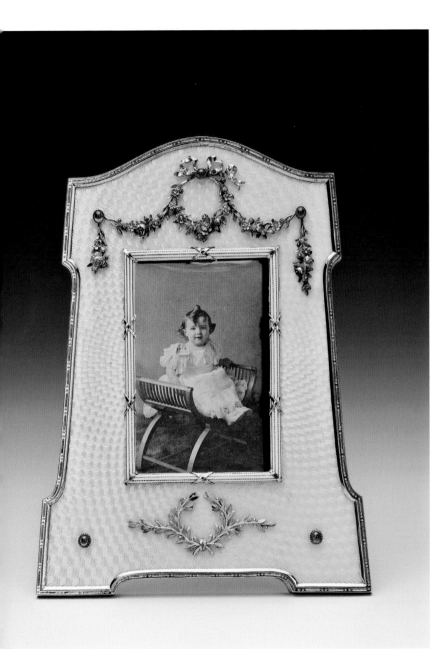

Frame with a photograph of Tsarevich Alexis
Acquired *c.*1906

Tsar Nicholas II and Tsarina Alexandra Feodorovna jointly bought this frame on 21 June 1906 for 106 roubles. It contains a contemporary photograph of their youngest child and only son, Alexis, then aged almost 2. By that time, Alexis had been diagnosed with haemophilia. Many pieces of Fabergé, including three Imperial Easter Eggs, were commissioned by Nicholas and Alexandra to commemorate his birth and different stages in his short life (1904–18). The Colonnade Egg of 1910, now in the Royal Collection, is surmounted by a cupid representing Alexis (see pp. 72–3). The silver-gilt frame is enamelled in pale blue guilloché in a geometric design and applied with ribbon-tied floral swags and a laurel wreath in four-colour gold set with cabochon rubies.

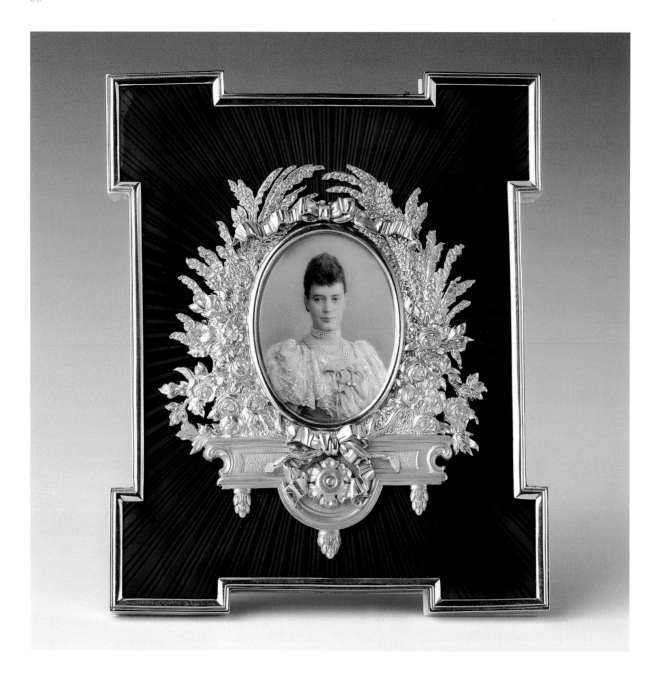

Frame with a miniature of Tsarina Maria Feodorovna
Acquired c.1895

Made in 1895, this frame is notable for its ornate coloured gold decoration
of flowers and wheat, which contrasts with the deep magenta sunburst guilloché
enamel. The frame contains an oval portrait miniature by the Danish-born
Johannes Zehngraf (1857–1908), a miniaturist who worked for Fabergé
and who painted Maria Feodorovna's portrait on several occasions – in addition
to numerous portrait miniatures of the British royal family. In this instance the
miniature is based on a photograph of 1894 by Alexander Alexandrovich Pasetti.

Column frame with miniature of King Christian IX
and Queen Louise of Denmark
Acquired c.1892

Frames mounted on columns were produced by Fabergé for the Imperial
Cabinet to be supplied as official gifts from the Tsar. Fabergé continued to
supply the model for other customers, including this example of bowenite, gold
and enamel which is likely to have been produced in connection with the golden
wedding anniversary of Queen Alexandra's parents. Christian IX (1818–1906)
married Louise of Hesse-Cassel (1817–1898) in 1842. Their six children all
made prestigious marriages, notably their two eldest daughters, Dagmar, who
became Tsarina Maria Feodorovna and Alexandra, who became Queen
Alexandra, consort of King Edward VII.

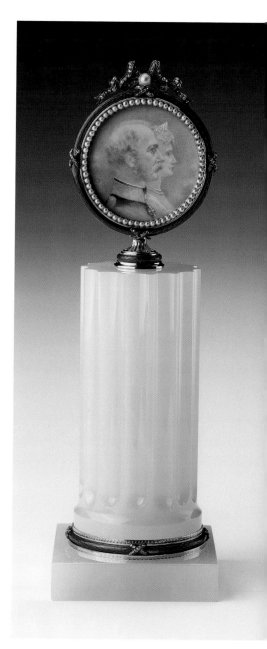

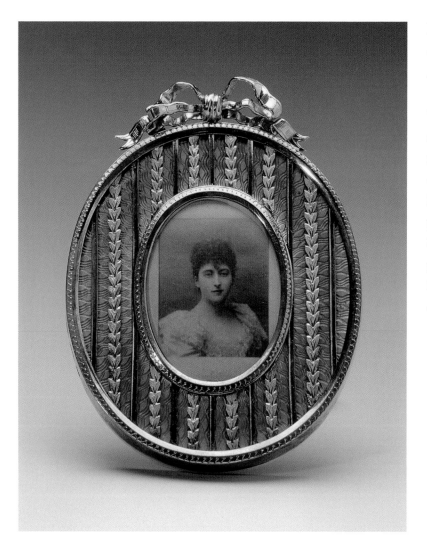

Frame with a photograph of Queen Maud
Acquired c.1896

The third daughter of King Edward VII and Queen Alexandra, Princess Maud (1869–1938) married Prince Charles of Denmark in 1896. He became King Haakon VII of Norway in 1905. This photograph, taken in the late 1890s, is set into an oval gold frame, with blue guilloché enamel and alternate gold bands of laurel leaves surmounted by a ribbon cresting.

Frame with enamelled view of Sandringham House
Acquired 1908

A number of boxes and frames with enamelled views of royal residences were purchased directly through the London branch by both King Edward VII and Queen Alexandra. They were either directly commissioned, or had their production carefully orchestrated to appeal to the King and Queen. This particular frame was purchased by King Edward in November/December 1908 at a cost of £67 and originally formed part of his daughter Princess Victoria's collection. It shows the west front of the house from the garden. It is one of three frames in the Royal Collection enclosing views of the Sandringham estate.

Frame with enamelled view of Sandringham Church
Acquired 1908

Although much smaller than the frame with a view of Sandringham House, this complements it in both the choice of materials and the technique of the sepia enamelled view. The royal family has worshipped at the parish church of St Mary Magdalene, Sandringham since King Edward VII, as Prince of Wales, purchased the estate in 1863. This frame was purchased by Earl Howe (1861–1929), from the London branch on 24 December 1908 for £35, and was almost certainly a Christmas present for Queen Alexandra that same year. Lord Howe served as Queen Alexandra's Lord Chamberlain from 1903 to 1925.

Crow
Acquired 1914

Carved in a combination of Kalgan jasper and obsidian, the pose of the bird is keenly observed from nature. Its eyes are of aquamarine and its legs and feet of silver-gilt. This crow was purchased by Queen Alexandra in 1914, its high price of £75 is indicative of the scale of the sculpture, which is much larger than the majority of Fabergé's animal portraits.

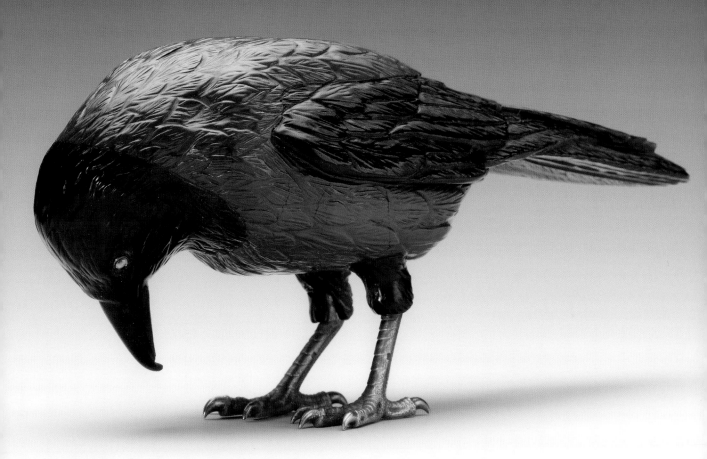

Portrait model of Persimmon
Acquired 1908

Persimmon was bred at the Sandringham Stud from St Simon out of Perdita H. Persimmon won the Derby and the St Leger in 1896 and the Ascot Gold Cup and Eclipse Stakes in 1897. According to her Journal, Queen Victoria was given a silver statuette of Persimmon by the Prince of Wales for Christmas 1896: 'I received many pretty presents, amongst which, from Bertie, a silver statuette of his horse Persimmon, which won the Derby.'[11] Fabergé's statuette is much later in date and was probably completed after Persimmon's death in February 1908. This portrait model in silver, mounted on a slab of nephrite, was made as part of the special commission placed by the King to have models of favourite dogs and horses from the Sandringham estate made by Fabergé. The sculptor was Boris Frödman-Cluzel (b. 1878), who, together with other Fabergé craftsmen, made life models in wax *in situ* in Norfolk. Bainbridge notes that the decision was taken to make Persimmon's portrait in silver owing to the fragility of his legs had they been carved from hardstone. Once the model had been cast in silver in St Petersburg, it was returned to the London branch where King Edward purchased it in November 1908 for £135. A month later on 21 December he bought six bronze copies of the model at a cost of £63.

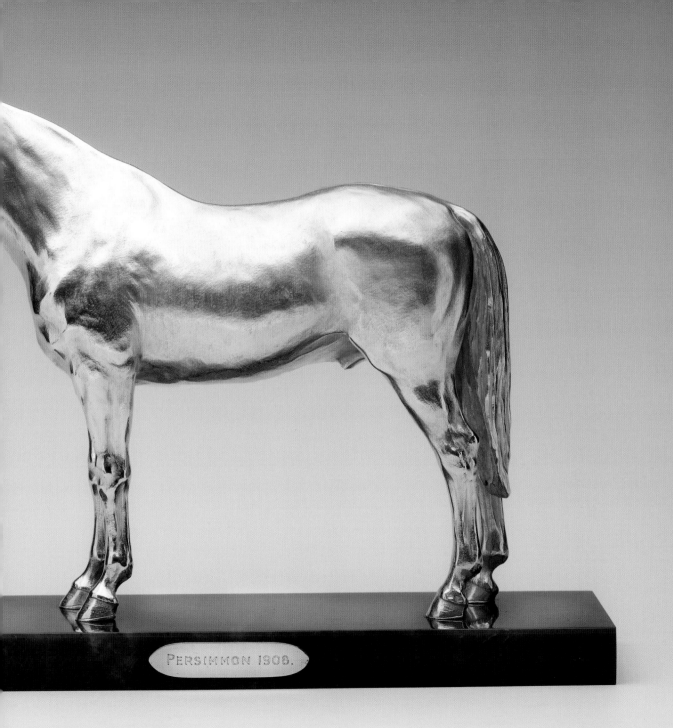

PERSIMMON 1908.

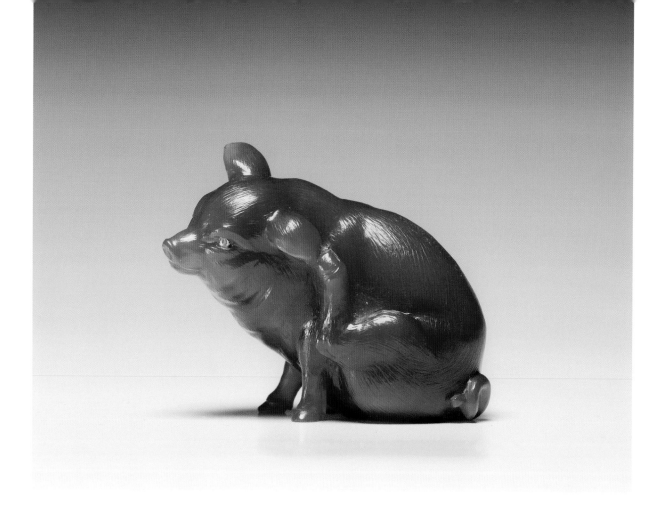

Pig
Acquired 1907

This carving was modelled as part of the Sandringham commission in 1907. The majority of the works from the commission were made of Russian hardstones, in this case agate. In order to ensure the finest raw material and the best stonecutters, Carl Fabergé established his own specialist workshop dealing purely with the remarkably rich variety of minerals mined across Russia, particularly in Siberia and the Urals. This pig demonstrates not only the acute observation of Fabergé's sculptors but also their skill in selecting a tiny piece of agate that would match the tonal variation of the animal's skin.

Litter of piglets
Acquired *c*.1900

Fabergé's craftsmen often combined hardstones to produce the effect desired – in this case to distinguish between the litter of sleeping piglets by using chalcedony and agate fixed to a gold mount underneath. The technique of combining stones was described by one of Fabergé's senior designers François Birbaum (who joined the firm in 1895) as 'mosaic sculpture'. The densely carved style and minute attention to detail are reminiscent of netsuke carving, a technique that fascinated Carl Fabergé, who owned a large collection of Japanese netsuke. Many of Fabergé's animal sculptures were produced in the workshop of the firm's third and final head workmaster Henrik Wigström, who succeeded to the role in 1903. There were twenty stone carvers working in one of the two workshops specialising in stone carving. This indicates the increased popularity of Fabergé's hardstone objects, especially animals. This particular sculpture was produced in Michael Perchin's workshop before 1903.

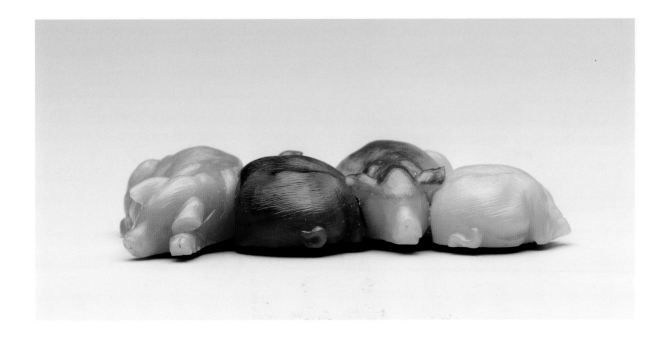

Caesar
Acquired 1910

King Edward VII's beloved Norfolk terrier Caesar was bred in about 1895 by the Duchess of Newcastle and presented to the King soon after the death of his Irish terrier, Jack. Caesar quickly became the King's favourite and followed him everywhere, often travelling abroad. The dog's mischievous personality is captured in this lively model made of chalcedony set with ruby eyes, mounted with an enamelled gold collar inscribed 'I belong to the King'. According to Bainbridge, Caesar accompanied the King when the animals modelled in wax by Fabergé's sculptors were unveiled in the Dairy at Sandringham on 8 December 1907, where among them was his own likeness. Caesar walked behind the King's coffin in the funeral procession from Westminster to Paddington on 20 May 1910. The dog died in 1914 and is buried in the grounds of Marlborough House. He is immortalised in stone, sitting at the feet of the King on his tomb in St George's Chapel, Windsor.

King Edward VII's funeral procession, 1910. RCIN 2935437

Kiwi
Acquired *c.*1908

A charming portrait of a kiwi in agate, with gold feet and a gold beak and set with rose diamond eyes. The precise provenance of this model is not known, but a kiwi was purchased from Fabergé's London branch in 1908 and is described in the ledgers of the branch as 'Kiwi (apterise) Brown agate, gold feet & beak'. It cost £26 5s and was bought by the Hon. Neil Primrose, younger son of the 4th Earl of Rosebury.

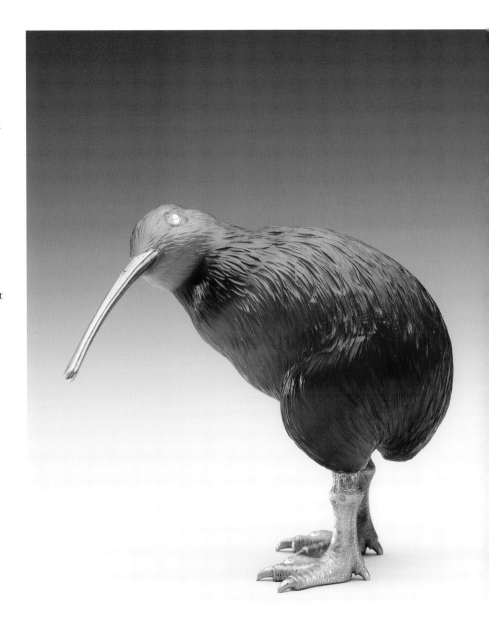

Elephant
Acquired *c.*1900

Elephants were one of Fabergé's most popular animal hardstone carvings and there are many examples in the Royal Collection amassed by successive generations from Queen Alexandra to Queen Elizabeth. This elephant demonstrates the keen observation of the modellers and the extraordinary skill of the lapidaries. The sense of the weight and bulk of the elephant and his slack, wrinkled skin as he walks along is palpable even on this diminutive scale.

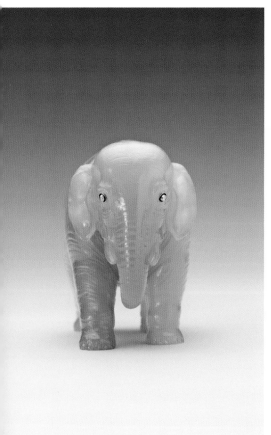
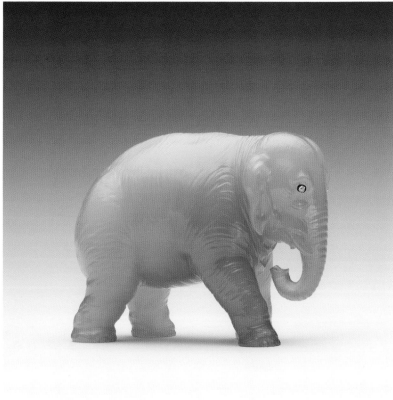

Chimpanzee
Acquired *c.*1908

This expressive carving is one of a number of apes in the Royal Collection. Monkeys, macaques, orang-utans and chimpanzees were all sold through the London branch of the firm. In July 1908 Queen Alexandra purchased an agate chimpanzee for £14 10s. The striations in the agate have been exploited to mimic the natural colouration of the ape and the texture of its fur. The eyes are olivines set in gold.

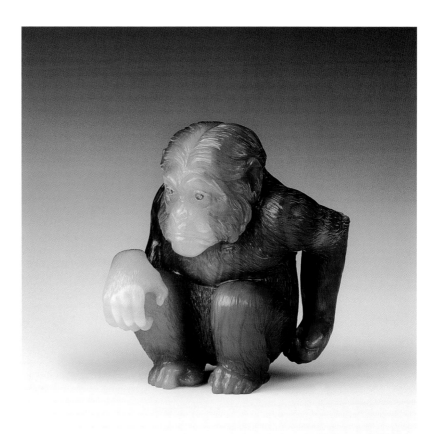

Doe and three baby rabbits
Acquired *c.*1913

This group carving is made from a single piece of agate with the eyes of the four animals picked out in rose diamonds. Grand Duchess Vladimir of Russia (1854–1920) purchased this from the London branch on 20 November 1913 and is presumed to have given it to Queen Alexandra for her birthday on 1 December. The Grand Duchess, wife of Grand Duke Vladimir Alexandrovich (brother of Tsar Alexander III), was a great connoisseur of Fabergé's work and she and her husband purchased and commissioned many pieces from the firm.

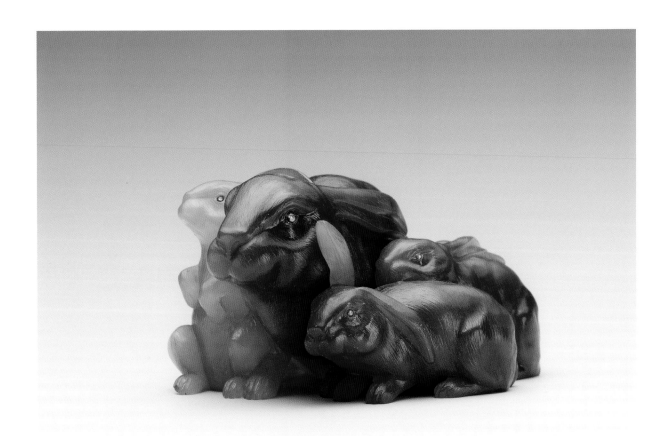

Dexter bull
Acquired 1908

This model is carved from obsidian, a natural black volcanic glass which, when highly polished, produces a velvety sheen. Fabergé used it for various objects, and it was particularly suited to his animal studies. The Dexter is the smallest British breed of cattle, usually black in colour and originating from the west of Ireland. It was first introduced into England in 1882 and was part of the herds kept on the estate at Sandringham, where this example was modelled from life. Queen Alexandra bought it in November 1908 for £44.

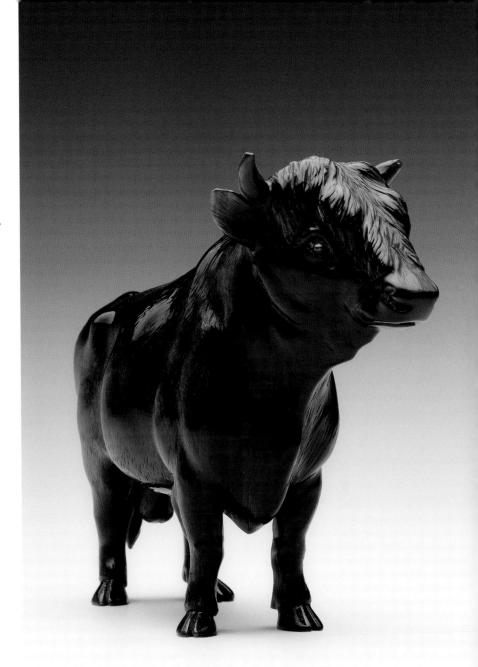

Parrot on a perch
Acquired *c.*1908

Queen Alexandra was very fond of
parrots. Contemporary photographs
show that several caged birds and
birds on perches were kept in her
Dressing Room at Sandringham,
and a caged cockatoo was kept in
the Saloon from the 1880s.
King Edward VII also kept caged
birds both at Marlborough House,
and later at Buckingham Palace.
This parrot is carved from agate
and rests on a perch of gold, white
guilloché enamel and silver-gilt set
with diamonds.

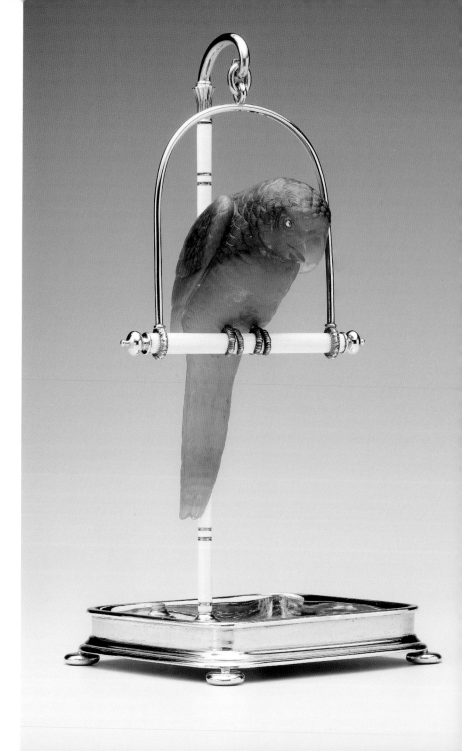

Seal on an ice floe
Acquired c.1900

The successful combination of
obsidian and rock crystal captures
the wet sheen of the seal's skin and
the dense ice block on which it rests.
There are four examples in the Royal
Collection of seals and sea lions
carved from obsidian and sitting on
rock crystal 'ice'.

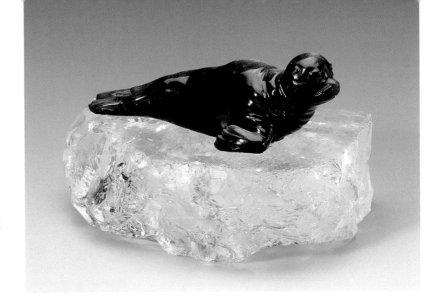

Queen Alexandra's dormouse
Acquired 1912

The Queen purchased this carving from
the London branch on 5 November
1912 at a cost of £33. The mouse is
carved from chalcedony and is fitted
with sapphire eyes; it nibbles gold
straws beneath its platinum whiskers.

This unique piece – no other Fabergé
dormouse on this scale exists – calls
to mind King Edward VII's dictum
'We do not want any duplicates', which
according to Bainbridge the King made
clear to him when considering the
formation of Queen Alexandra's
collection of Fabergé animals.[12]

Ostrich
Acquired *c*.1900

Photographs of Fabergé's design room
on the top floor of his St Petersburg
headquarters show a wide variety of
wax models of animals and birds and
some taxidermal studies used by the
sculptors. This ostrich is carved from
a single piece of variegated chalcedony
and is fitted with red gold legs and
rose diamond eyes.

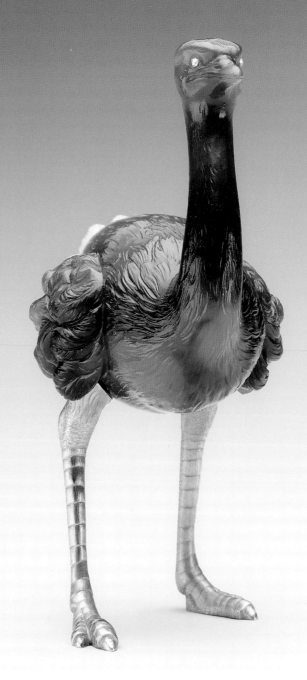

Lily of the valley
Acquired 1899

The delicate lily of the valley was the favourite flower of Tsarina Alexandra Feodorovna. The imperial family, like other members of the wealthy in Russian society, were able to afford flowers imported from the south of France, which were kept on ice to preserve their freshness during the long train journey to Russia. Fabergé was able to replicate the charm and beauty of flowers through the ingenious use of precious metal and stones. The stems of this flower are of gold, the leaves of Siberian nephrite and the bell-shaped flowers of pearl edged with tiny rose diamonds, all resting in a vase of rock crystal carved to replicate the refraction of a flower stem in water. This flower was purchased by Tsar Nicholas II and Tsarina Alexandra Feodorovna in December 1899 for 250 roubles and is presumed to have been a gift to Queen Alexandra.

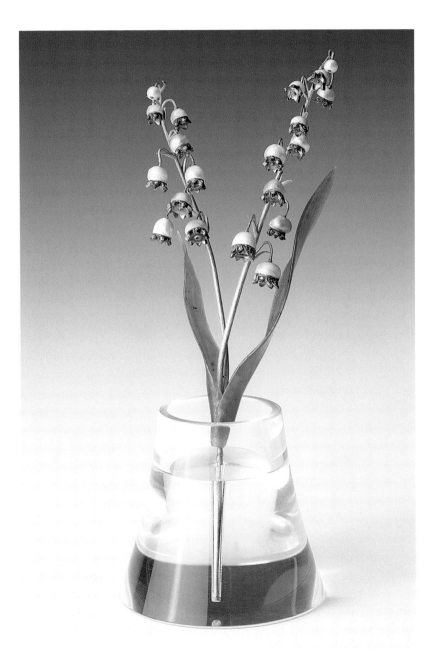

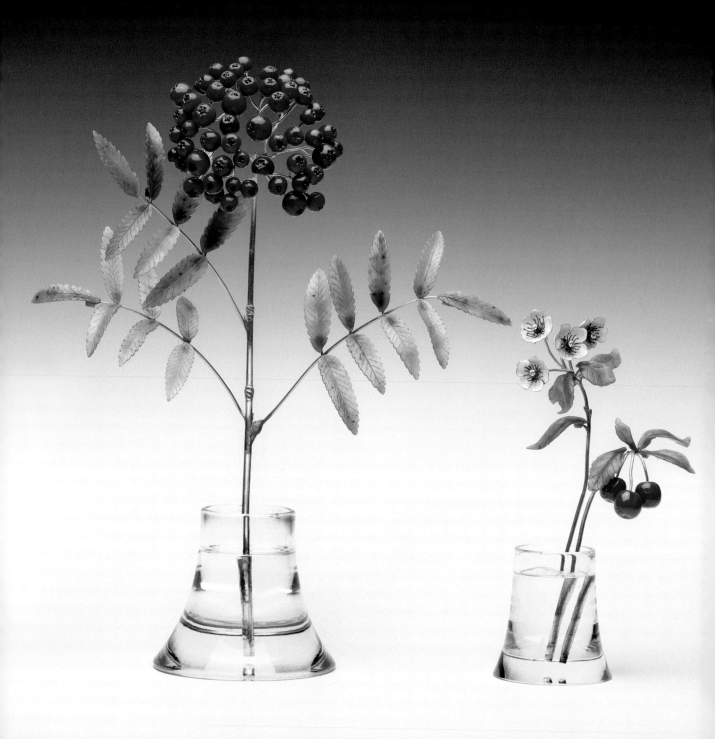

Rowan spray
Acquired *c.*1900

This remarkably life-like study of rowan incorporates purpurine ranging from bright red fresh berries to purple for the blackened berries shrivelling in decay. The leaves, of mottled Siberian nephrite, are delicately carved to show every vein, even on the underside where the stonecutters and polishers have taken pains to replicate the matt surface. It was acquired by Queen Alexandra, who bequeathed it to her daughter Princess Victoria, following whose death in 1925 it passed to King George V.

Wild cherries
Acquired *c.*1900

Two separate gold stems support in one instance white enamelled cherry blossom and in the other, ripe red cherries carved from purpurine and suspended from gold stems and nephrite leaves. A vitreous compound, purpurine was manufactured by the Russian Imperial Glass Factory and was the only man-made material used in the production of the flowers. Although produced in relatively small numbers, Fabergé's botanical studies were highly prized as decorative objects. They were a welcome reminder of the short Russian spring and summer and an escape from the long, harsh winter. This flower formed part of Queen Alexandra's collection.

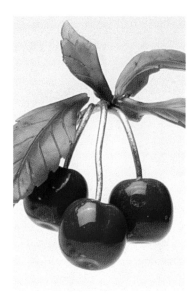

Philadelphus
Acquired *c*.1900

A design for philadelphus, closely related to this example, exists in an unpublished album of designs from Henrik Wigström's workshop (shown on p. 53). Philadelphus, or mock orange, was well known to inhabitants of Russia – particularly in the region of St Petersburg where during the early part of July its intoxicating scent filled gardens and wafted through open windows of dachas and estates. The popularity of the flower explains why several examples were made by Fabergé.

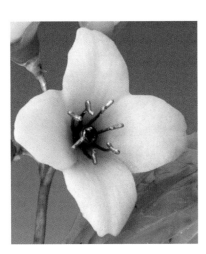

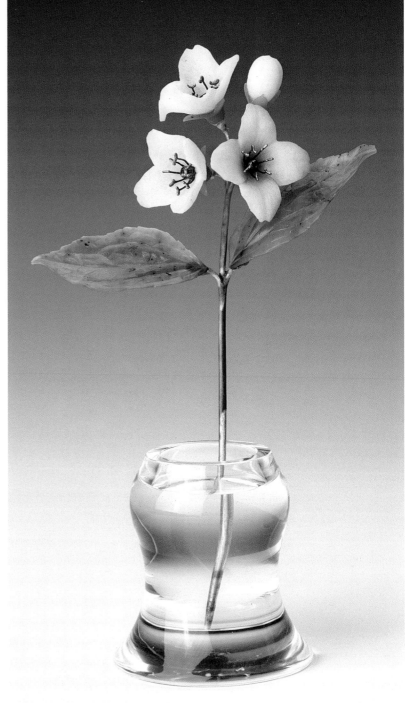

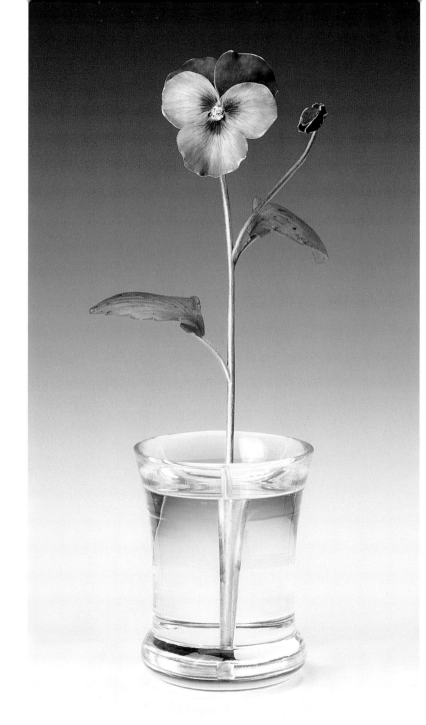

Pansy
Acquired *c*.1900

The pansy was almost as popular as the philadelphus in Russia, flowering in spring and early summer and during the White Nights of high midsummer. This example shows the remarkable skill of the enameller in imitating the papery matt surface of the petals. It is one of three Fabergé pansies in the Royal Collection owned by Queen Alexandra.

A plate from an album of watercolour designs by Henrik Wigström.

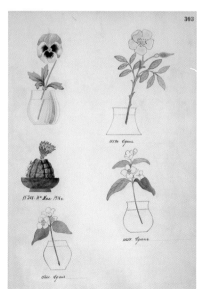

Chrysanthemum
Acquired 1908

Queen Alexandra owned 22 of
the 26 Fabergé flowers now in the
Royal Collection but, according to
the ledgers of the London branch,
purchased only one herself –
a raspberry plant in June 1909.
This confirms that the majority,
including this chrysanthemum,
were presented to her as gifts.
It was the most expensive flower
study purchased at the London
branch (for £117 in December
1908), and was bought by Stanislas
Poklewski-Koziell, a councillor at
the Russian embassy in London and
a good friend of King Edward VII.
The large enamelled flower heads
are held on gold stems, strengthened
inside by steel in order to support
the weight of the flowers.

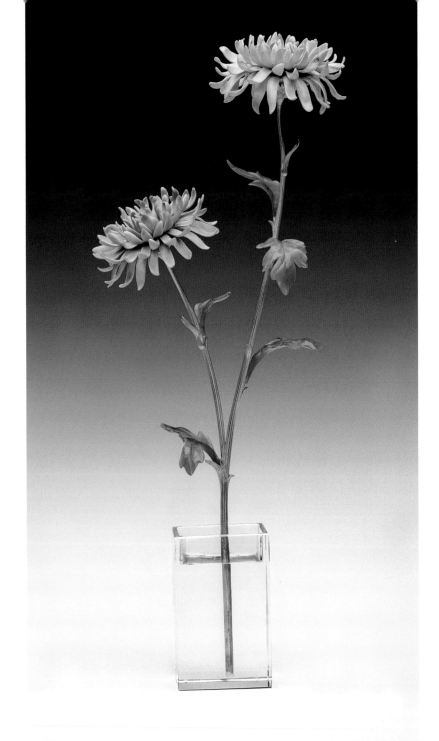

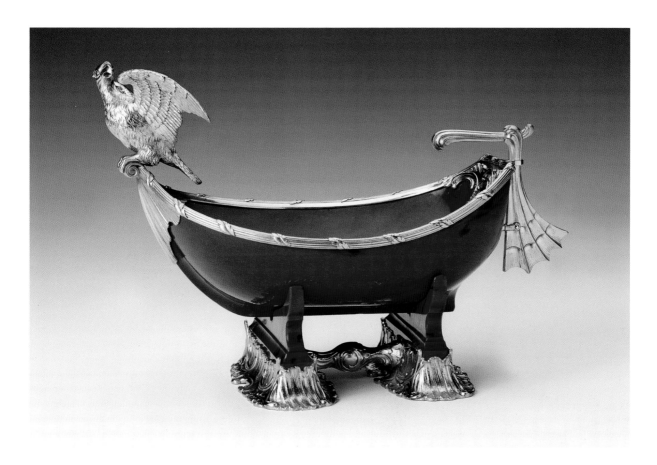

Kovsh
Acquired *c.*1900

This large-scale kovsh (traditional Russian drinking vessel) of purpurine is mounted in silver-gilt in the form of a boat. It rests on a separate base of glass coloured in imitation of purpurine, with silver-gilt mounts chased to appear like lapping waves. The kovsh was made in the workshop of Julius Rappoport, who became Fabergé's most important supplier of silver objects. The large scale of this kovsh, together with its eagle mount, may suggest that it was originally purchased by the imperial family, but its means of entry into the Royal Collection are not precisely known.

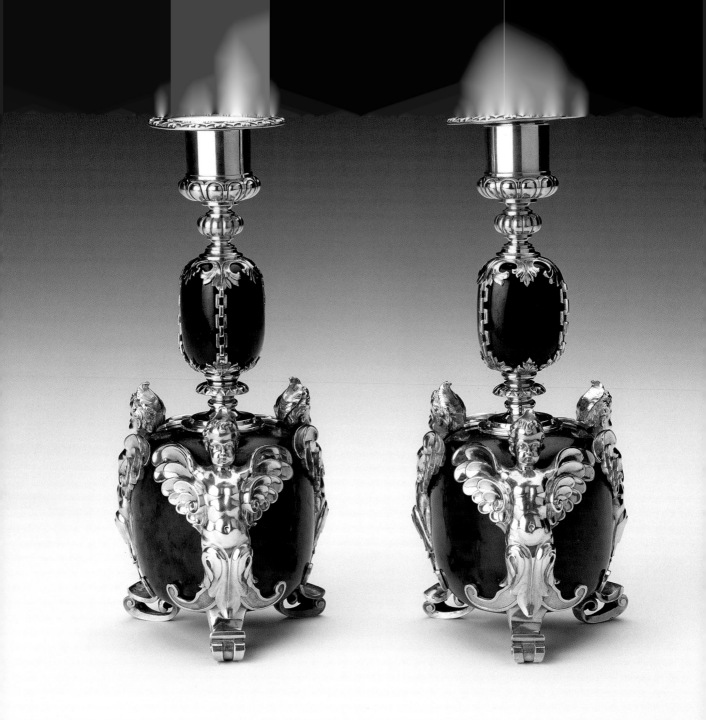

Pair of candlesticks
Acquired 1890s

The workmaster Rappoport was
also responsible for these nephrite
candlesticks with silver mounts in
the baroque style. Nephrite was one
of the hardstones used most often
by Fabergé. It was found in gigantic
boulders near Lake Baikal in Siberia
and the Sayan Highlands along the
River Onat in the eastern part of
the Altai Mountains on the border
of Mongolia. The boulders could
only be moved in winter on frozen
ground and were carried on horse-
drawn sledges across the tundra to
St Petersburg, where they would be
cut open to reveal the stone, which
when cut into thin sheets reveals
its rich colour and translucency.
These candlesticks were acquired
by King Edward VII and Queen
Alexandra at an unrecorded date.

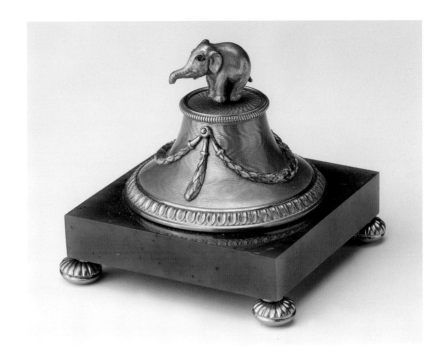

Bell push
Acquired c.1900

Bell pushes were among the myriad of practical objects that Fabergé produced.
These were not purely functional, but were highly decorated desk accessories,
embellished with enamel, gold of different colours and precious stones. Here
the pushpiece is in the form of a silver elephant set with cabochon ruby eyes.
This is almost certainly a reference to Queen Alexandra's native Denmark, where
the elephant is incorporated in the design of the senior Danish order of chivalry.
The elephant stands on a tapered platform of salmon-pink guilloché enamel
and a nephrite base. Tsarina Maria Feodorovna purchased eight bell pushes
decorated with elephants from the Fabergé firm and this example is quite likely
to have been a gift from her.

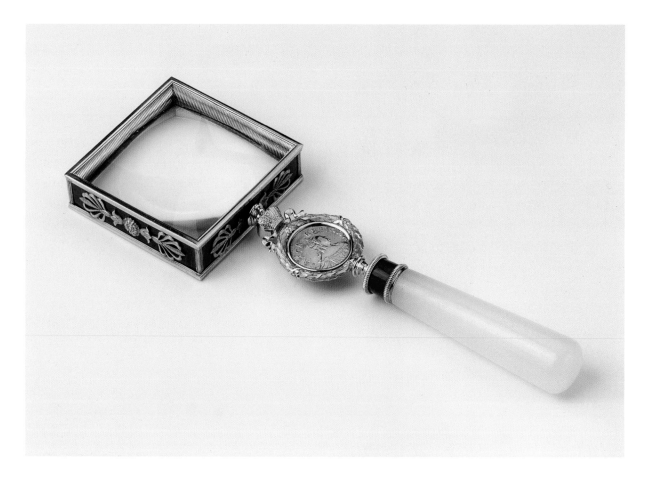

Magnifying glass
Acquired *c.*1900

The frame of the lens is applied with mounts in the neo-classical taste, over blue guilloché enamel. The handle is of carved and polished chalcedony with a matching band of blue enamel; it is joined to the lens by coloured gold mounts in the form of a laurel wreath surmounted by the Russian imperial crown, enclosing a gold rouble coin from the reign of Tsarina Elizabeth and dated 1750.

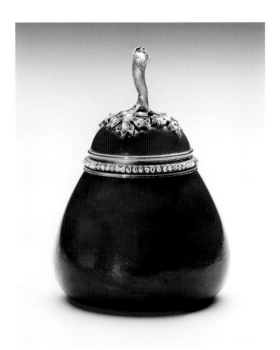

Pear-shaped pot
Acquired *c*.1900

Even the humblest of objects, in this case a small pot and cover, was treated with exacting standards by Fabergé and his craftsmen. Carved from nephrite, the pot replicates the form of a pear, complete with reeded gold stem terminating in a diamond and leaves in gold, highlighted with diamonds. The rim of the base is also set with a band of rose diamonds. The pot forms part of a large group of desk accessories in the Royal Collection, often in nephrite, many of which were acquired by King Edward VII and Queen Alexandra.

Seal
Acquired *c*.1900

The handle of this seal is of gadrooned smoky quartz, set into gold with a band of green guilloché enamel with applied rubies. The matrix of agate is engraved 'Victoria'. The seal belonged to Princess Victoria, daughter of King Edward VII and Queen Alexandra, who was an enthusiastic collector of Fabergé and inherited many pieces from her mother's collection, as well as regularly buying from the London branch. Her collection was largely inherited by her brother, King George V.

Vase
Acquired 1908

This vase was presented to King Edward VII by his nephew by marriage Tsar Nicholas II when the King visited Reval (now Tallin) in June 1908. The King was accompanied by Queen Alexandra and Princess Victoria, and they departed on the Royal Yacht *Victoria and Albert* on its maiden voyage, to be met by the Tsar and members of the imperial family on their yachts *Standart* and *Polar Star*.

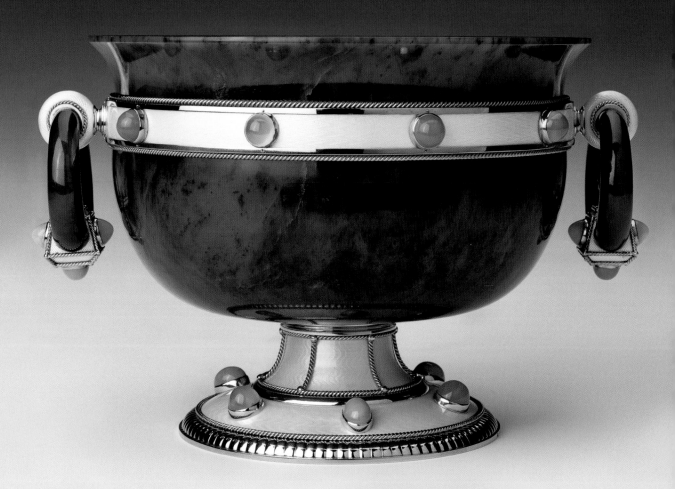

The meeting involved diplomatic discussions but was also a family reunion with banquets and balls. The nephrite vase is mounted in silver-gilt and gold with white guilloché enamel, and is set with cabochon moonstones and chalcedony. According to the accounts of the imperial cabinet, it was paid for on 23 May 1908 (2,500 roubles) but was not delivered to the King until November 1908. In return, King Edward VII presented his nephew with a naval sword made by Wilkinson and inscribed *For His Imperial Majesty Emperor of All Russia Nicholas II from His Loving Uncle Edward Reval 1908*. The sword commemorated the King's appointment of the Tsar as an admiral of the fleet in the Royal Navy, a compliment which the Tsar returned by according the King a similar honour in the Russian navy.[13] The sword is now in the museum at Tsarskoë Selo, outside St Petersburg.

Below: Dejeuner menu signed by Tsar Nicholas II and others. RCIN 2917297

Below left: King Edward VII and Tsar Nicholas II at Reval in 1908. RCIN 2916998

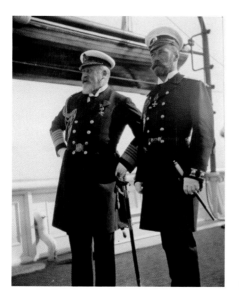

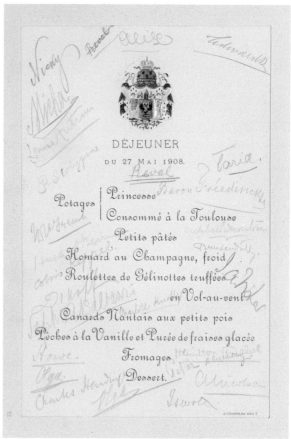

Chelsea Pensioner
Acquired 1909

Fabergé's human figures are among
the firm's rarest creations. Around
fifty are recorded and they are,
after the Imperial Easter Eggs, his
most important works owing to the
complexity of their production.
The majority are of traditional
Russian types such as soldiers and
ice-carriers and some are actual
portraits. This model is of a typically
English figure: the Chelsea Pensioner.
Chelsea Pensioners are the
in-pensioners of the Royal Hospital,
Chelsea, established by Charles II
in 1682 for veteran soldiers of
meritorious service. They are housed
in Sir Christopher Wren's building
in Chelsea, London. The model was
purchased by King Edward VII on
his last visit to the London branch,
22 November 1909, at a cost of £49
15s. The face and hands are made
of aventurine quartz, the coat is of
purpurine, the legs and hat are
of jasper and the cane, buttons and
medals are of gold.

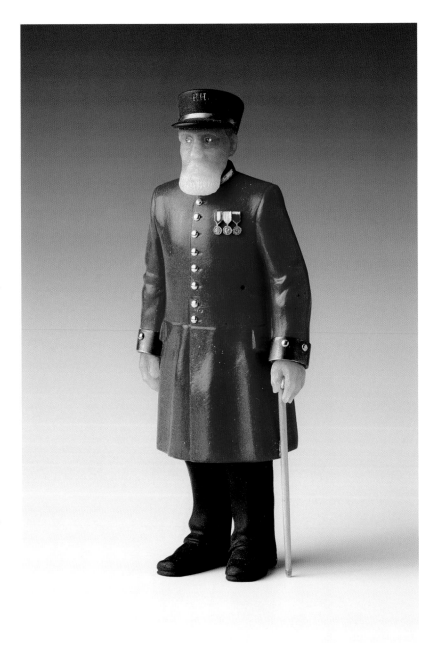

Bust of Tsar Alexander III
Acquired *c*.1900

This miniature bust, in smoky quartz on a column of nephrite applied with
the imperial double-headed eagle, was produced after the death of the Tsar in
November 1894. Another portrait bust by Fabergé exists; it was made in 1912,
possibly in connection with the Romanov dynasty's tercentenary, celebrated in
1913. This bust formed part of Queen Alexandra's collection. She was the
Tsar's sister-in-law and it may have been a present to her from the Dowager
Tsarina Maria Feodorovna. A silver portrait bust of Alexander III is listed in
the items belonging to Maria Feodorovna and confiscated from the Anichkov
Palace in 1917. Fabergé had earlier supplied a gold bust of Alexander III as
the surprise inside the Alexander III Commemorative Egg, given to Maria
Feodorovna at Easter 1909 by Tsar Nicholas II. Reflecting the close dynastic
links between the families, the Tsar and Tsarina often saw their British royal
relations, whether in England, Russia or Denmark. Queen Victoria recalled
a visit paid by Alexander III (then the Tsarevich) and Maria Feodorovna
(Minny) in her Journal on 1 July 1873: 'The Csarevitch led me in [to dinner],
as 36 years ago his Grandfather, the Emperor Nicholas had done. He is very
goodnatured. I wore the Russian order, & sat between him & Minny.'[14]
In a telegram to Queen Victoria at the time of the Tsar's death, the new
Tsar Nicholas II wrote 'dearest beloved father has been taken from us.
He gently went to sleep'.[15]

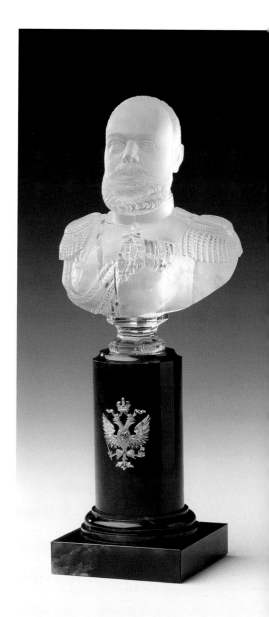

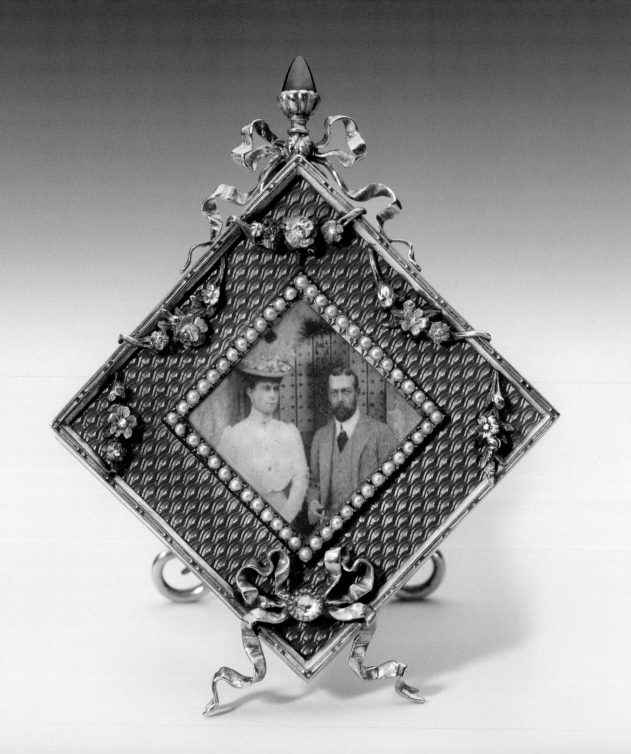

King George V and Queen Mary

1865–1936 and 1867–1953

WHEN DUKE OF YORK, Prince of Wales and King, George V was a
regular customer at Fabergé's London branch and often mentioned his
visits in his diary. For example on 3 May 1903 he writes that 'he [Fabergé] has just
come over from Russia, we bought about 43 of his lovely things.'[16] Bainbridge
recalls the Prince of Wales's visits, noting that 'The Prince sometimes came alone
at eleven o'clock in the morning.'[17]

Invoices in King George V's accounts record several purchases from the firm,
which reveal a particular interest in animal carvings, many of which had been
commissioned by his father. Among the portraits of dogs that formed part of the
Sandringham commission were several that belonged to King George V. The King
also purchased a wild boar, a kangaroo and a water buffalo (p. 104). Perhaps he
was influenced by seeing these animals on his tours abroad as well as in London,
where on 4 June 1911 he noted his diary: 'In the afternoon we took the children
to the Zoo and inspected my collection of animals which have been given me by
South Africa, they have just arrived.'[18]

The King formed an important collection of boxes and cigarette cases, many
of which were in use and all of which were listed with their provenance in his
inventory of cigarette cases dated 1936. In addition, contemporary photographs
of Buckingham Palace show that the King regularly used Fabergé desk accessories,
including clocks, seals and stamp boxes. Like King Edward VII, he also appreciated
the more amusing of Fabergé's objects. King Edward VII had been given a cigar
lighter in the form of a frog by Queen Alexandra in 1906. For Christmas 1929,
the royal family gave King George V a Fabergé automaton in the form of a
clockwork elephant (p. 114).

Queen Mary was passionately interested in the decorative arts and was a
renowned collector. Her interest in Fabergé's work lasted throughout her life and
in 1949 Bainbridge described her 'as the greatest surviving connoisseur of Fabergé's
craftsmanship'.[19] Queen Mary purchased a large number of pieces, such as boxes
and cigarette cases, which she gave to the King. She in turn received many pieces

PP3. 3/588

К. Фаберже C. Fabergé

ПРИДВОРНЫЙ ЮВЕЛИРЪ. JOAILLIER DE LA COUR.

СТ. ПЕТЕРБУРГЪ ST. PÉTERSBOURG

МОСКВА · ОДЕССА · ЛОНДОНЪ MOSCOU · ODESSA · LONDRES

173, NEW BOND STREET, W.

December 15th 1913.

His Majesty, THE KING.

1913.			£	s	d	
November 13.	KANGAROO, nephrite.		£ 23	-	-	No.20716.
	INDIAN COW, grey calcedony, ivory.		41	-	-	No.20468.
	BEAR (Australian Koala) yellow agate,&c.		38	-	-	No.22497.
	CAMEL, Chinese jade, 2 rubies.		18	-	-	No.21434.
	CIGARETTE CASE, white bird's eye wood.		4	10	-	No.20580.
	ditto, birchwood etc.		2	10	-	No.17794.
	ditto. white bird's eye wood.		7	-	-	No.15880.
		£	134	-	-	
	Less discount.		13	8		
		£	120	12	-	

1913
Dec.ʳ 16 62
Received with
thanks
£120. 12.
pp. G. FABERGE

ONE
PENNY

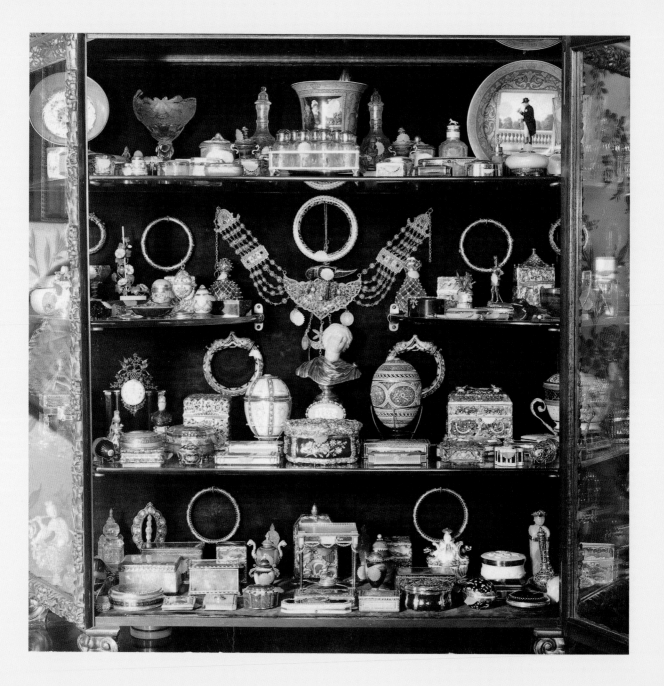

Display cabinet showing pieces from Queen Mary's Fabergé collection at Buckingham Palace, c.1950.

as gifts from her Russian relations, including a snuff bottle given to her by the Dowager Tsarina Maria Feodorovna (p. 99). She also received gifts of Fabergé which were placed in her famous Dolls' House, completed in 1924 and designed by Sir Edwin Lutyens (1869–1944).

Following the revolution in 1917, works of art formerly in the possession of the imperial family were confiscated and many were eventually sold off by the Antikvariat, Lenin's bureau established to sell state treasures to the West. At first the market for such pieces was small, but through her own acquisitions Queen Mary was instrumental in influencing a generation of collectors who sought to acquire pieces with imperial provenance. In the 1930s King George V and Queen Mary made significant additions to the collection by purchasing three of the Imperial Easter Eggs formerly in the possession of Tsarina Alexandra Feodorovna (pp. 70–77). However, the Queen was not only interested in collecting Fabergé; she was a regular and enthusiastic visitor at sale views and exhibitions – including the 1935 Russian exhibition held in Belgrave Square.

Queen Mary paid regular visits to West End dealers, notably Wartski, who had established a branch in London in 1911. In the 1930s her visits to the firm's premises were listed in the Court Circular. An important innovation was introduced by Queen Mary when she began to make loans from the Fabergé collection to exhibitions. This had commenced in 1935 with the Belgrave Square exhibition and continued in 1948 when she lent a miniature table (p. 111) to the Antique Dealers' Fair and Exhibition at Grosvenor House.

The Basket of Flowers Egg
Acquired 1933

Commissioned by Tsar Nicholas II as an Easter present for Tsarina Alexandra Feodorovna in 1901, the Basket of Flowers Egg cost 6,850 roubles. The Tsarina kept the egg in her study at the Winter Palace. Each of the 50 Imperial Easter Eggs made by Fabergé was unique, its design and execution of the highest possible standard using the finest raw materials. The bouquet of wild spring flowers would have particularly appealed to Tsarina Alexandra, who owned several of Fabergé's flower studies. Pansies, cornflowers, daisies, mock orange, oats and grasses are set into an egg-shaped vase of oyster guilloché enamel filled with moss made of green gold. The vase is applied with gold and rose diamonds in a trellis pattern. The handle is similarly set with diamonds and applied with bows. According to a description of the egg in an inventory of the Easter eggs kept at the Winter Palace dated 1909, the vase was 'entirely covered with white enamel'. Due to damage sustained in the aftermath of the revolution, the base was re-enamelled in blue, possibly between Queen Mary's acquisition of the egg in 1933 and a photograph of it published in 1949. A note of its condition made in 1933 records that the enamel on the leaves and in two places on the basket was damaged. The egg was exhibited at the charity exhibition held under the patronage of Tsarina Alexandra Feodorovna in March 1902 at the mansion of Baron von Dervis in St Petersburg. It was confiscated from the Anichkov Palace by the provisional government in 1917 and taken to the Moscow Kremlin Armoury, where it was valued at 15,000 roubles. In 1922 it was transferred to the Sovnarkom (the government of the early Soviet republic) and in 1933 it was sold for 2,000 roubles by the Antikvariat (the state-run organisation 'for the collection and conservation of treasures'). According to her list of bibelots, Queen Mary acquired this egg in the same year, but no invoice for its purchase survives.

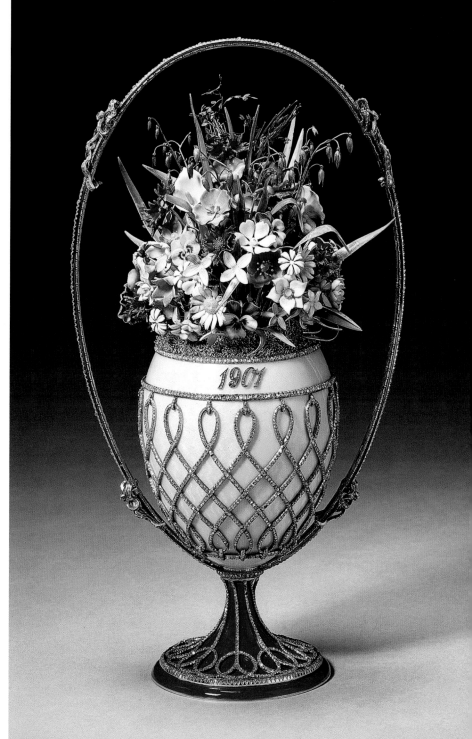

The Colonnade Egg
Acquired 1931

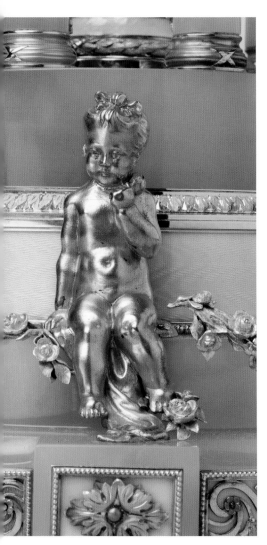

This Imperial Easter Egg – which incorporates a rotary clock in its design, the movement supplied to Fabergé by Henry Moser & Cie – is in the form of a classical temple. The colonnade of pale green bowenite columns supports the pink guilloché enamelled egg, surmounted by a cupid. Below a pair of platinum doves sits on a truncated column and around the base four female silver-gilt cherubs hold garlands of roses in red, white, green and yellow gold. This Easter egg is an allegory of the imperial family in 1910. The enduring love between the Tsar and Tsarina is represented by the pair of doves; their four daughters, Olga (b. 1895), Tatiana (b. 1897), Maria (b. 1899) and Anastasia (b. 1901) – collectively known by their parents as OTMA – are represented by the four cherubs; and the Tsarevich Alexis (b. 1904) is represented by the cupid. Early photographs of the egg and a description of it in a Fabergé album of the Imperial Easter Eggs presented to Tsarina Alexandra Feodorovna between 1907 and 1916 show that the cupid originally held an arrow in his hand to point to the hour. The egg was the Tsar's gift to Tsarina Alexandra for Easter 1910 and cost 11,600 roubles. In 1917 it was confiscated from the Anichkov Palace, and in 1922 it was transferred to the Sovnarkom. The dealer Emanuel Snowman brought it to London and, according to a manuscript annotation by Queen Mary in her copy of Bainbridge's autobiography, *Twice Seven*, it was acquired by her in 1931 and given to King George V.

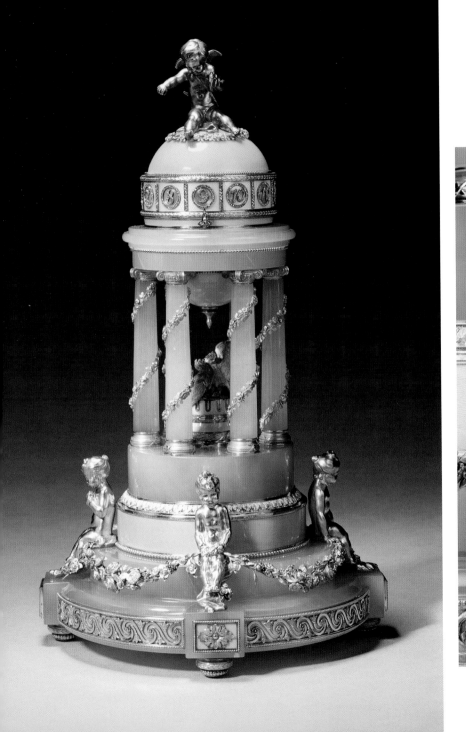

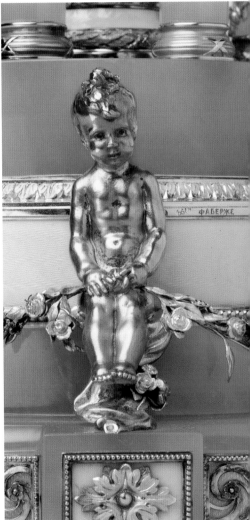

The Mosaic Egg
Acquired 1933

Technically one of the most sophisticated and extraordinary of Fabergé's Imperial Easter Eggs, the Mosaic Egg retains its 'surprise'. It takes the form of a medallion painted on ivory with the portraits of the five children of Tsar Nicholas II and Tsarina Alexandra on one side and a basket of flowers and their names on the other, on a stand surmounted by the Russian imperial crown, held within the egg by gold clips. The egg was the Tsar's Easter gift to his wife in 1914, but the original invoice was destroyed and the cost is therefore unknown. The Tsarina's monogram and the date *1914* are set beneath a moonstone at the apex of the egg. It comprises a platinum mesh into which tiny diamonds, rubies, topaz, sapphires, demantoid garnets, pearls and emeralds are fitted – perfectly cut, polished and calibrated to fill the spaces. This extraordinary technical feat is all the more impressive because the platinum is not welded but cut. The five oval panels around the centre of the egg feature a stylised floral motif, replicating the technique of *petit-point*. In the list of confiscated treasures transferred from

the Anichkov Palace to the Sovnarkom in 1922, the egg is described thus: 'I gold egg as though embroidered on canvas'. The designer, Alma Theresia Pihl, was inspired to produce the needlework motif when watching her mother-in-law working at her embroidery by the fire. Alma Pihl came from a distinguished family of Finnish jewellers employed by Fabergé. Her uncle, Albert Holmström, took over his father August's workshop and was the workmaster responsible for the production of this bejewelled egg. The egg was confiscated in 1917 and sold by the Antikvariat in 1933 for 5,000 roubles. It was purchased by King George V from Cameo Corner, London, on 22 May 1933 for £250 'half-cost', probably for Queen Mary's birthday on 26 May.

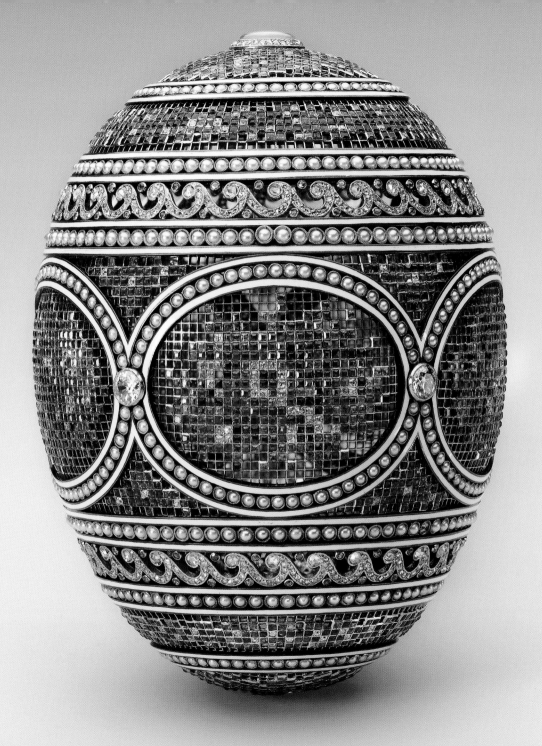

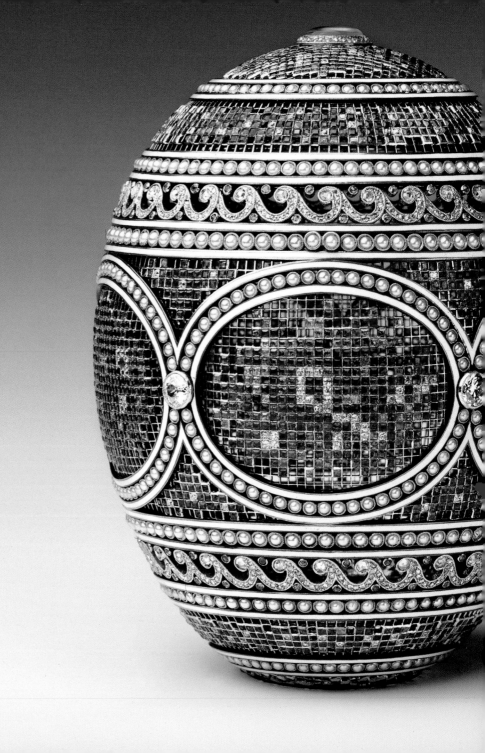

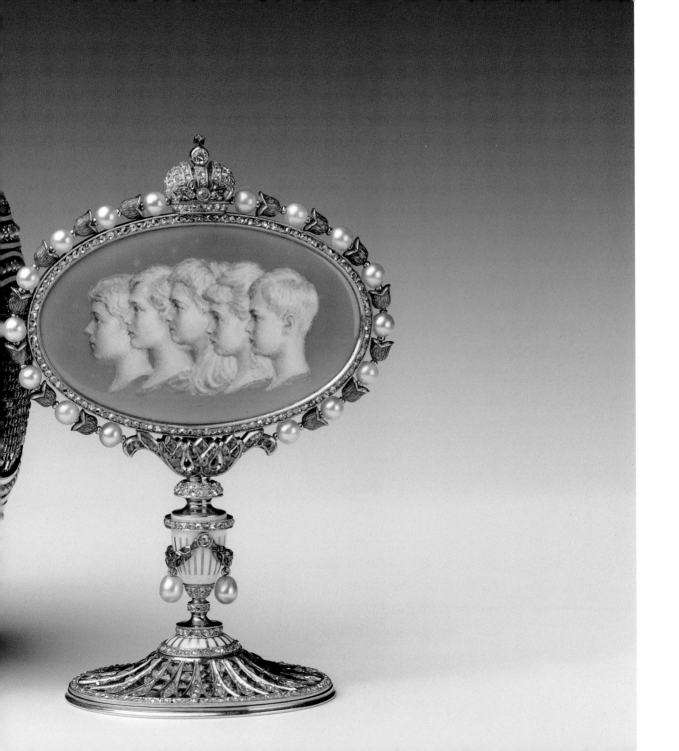

Easter egg
Acquired 1933

In 1898 Alexander Kelch, a wealthy Russian of noble birth involved in mining enterprises in Siberia, commissioned a series of seven Easter eggs from Fabergé which were as lavish as those made for the imperial family. In early documentation four of the seven eggs were thought to be missing imperial eggs, but that was discounted when original invoices for the imperial eggs came to light. All seven of the Kelch eggs were made in the workshop of Michael Perchin. This egg is the second of the series and bears the initials of Kelch's wife Barbara under a portrait diamond at the top and the date *1899* at the bottom (see details overleaf). The egg is divided into 12 translucent pink and enamel panels, decorated with ribbon and foliate motifs in blue, with chased gold borders overlaid with enamel roses. A similar method of dividing the panels of an egg was used by Fabergé for two Imperial Easter Eggs: the Danish Palaces Egg of 1890 and the Twelve Monogram Egg of 1895. Later eggs in the series were certainly inspired by those in the possession of the imperial family. The 'surprise' which the egg once contained is missing and was not with it when King George V purchased it from Wartski as a Christmas present for Queen Mary in 1933.

Overleaf: The ends of the Easter egg (details).

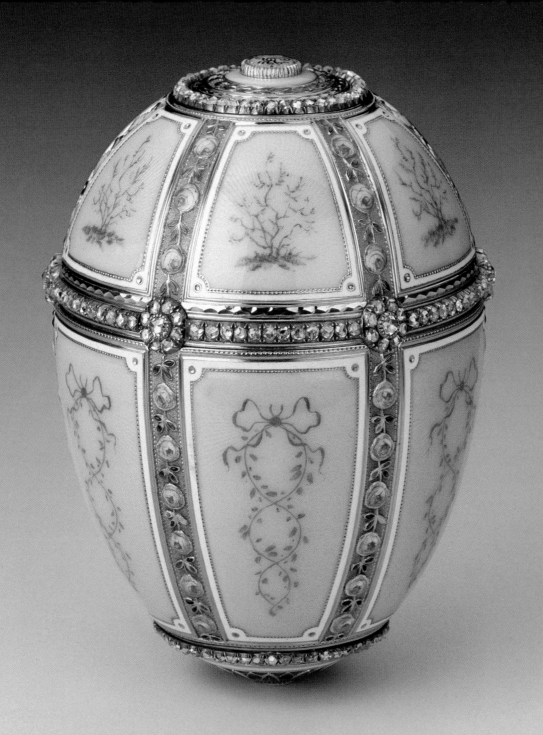

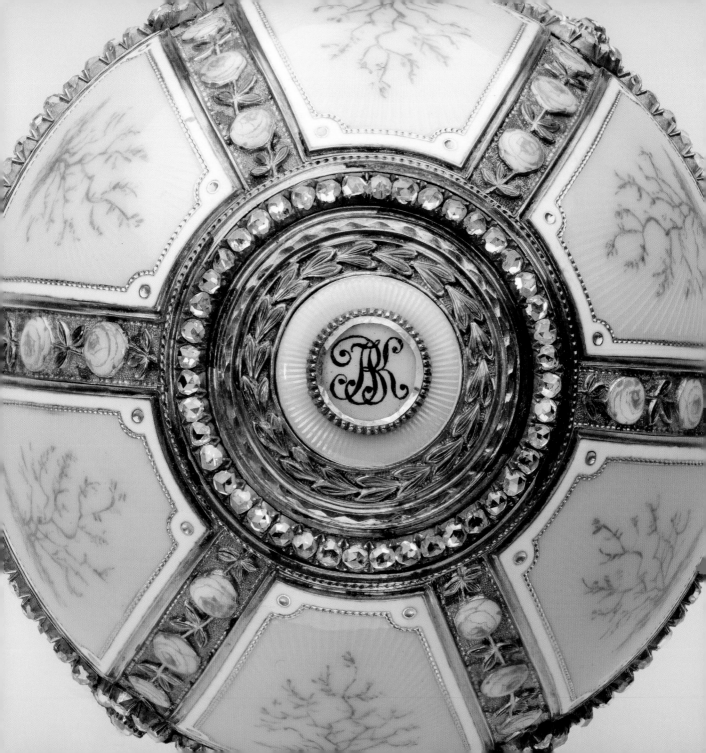

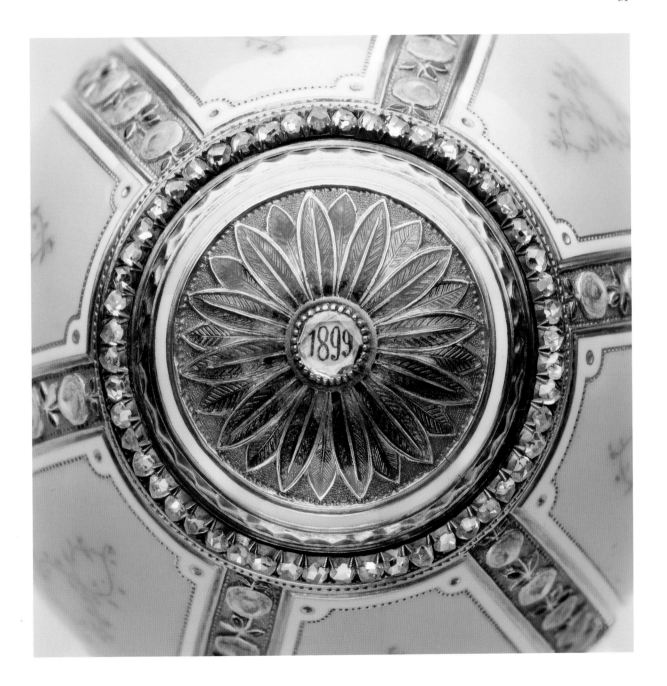

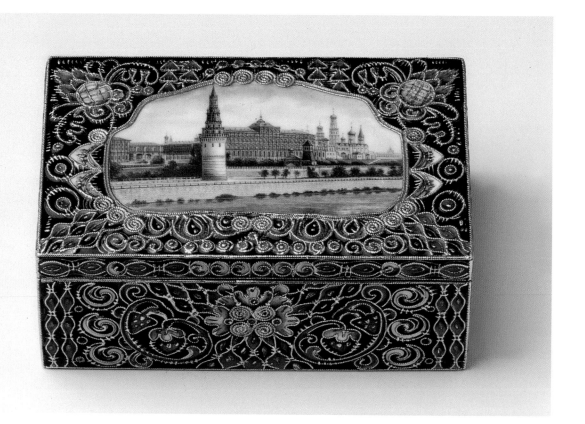

**Box with a view
of the Kremlin**
Acquired 1920

In October 1920 the daughter of Marie, Duchess of Saxe-Coburg-Gotha, gave
the King this box. It is typical of the pieces produced in the Old Russian or
Pan-Slavic style of Fabergé's Moscow workshops, which were established in
1887. Fabergé's Moscow clientele were more conservative than those of the
Europe-oriented St Petersburg branch. Sculptural silver pieces inspired by native
folklore and history and decorated in traditional champlevé, plique-à-jour and
cloisonné enamel catered to the rapidly growing merchant class conscious of
their Slavic heritage. The cloisonné enamel on this box in muted tones of green,
blue and mauve is typical of such pieces.

Box
Acquired *c.*1920

This fan-shaped box formed part of Queen Mary's collection. The body of
the box is of bloodstone while the lid, in the shape of a fan, is of alternate
tooled gold and pink guilloché enamelled stripes, edged with brilliant diamonds.
The handle of the fan forms the hinge and is set with pearls, while the
pushpiece is a cabochon moonstone.

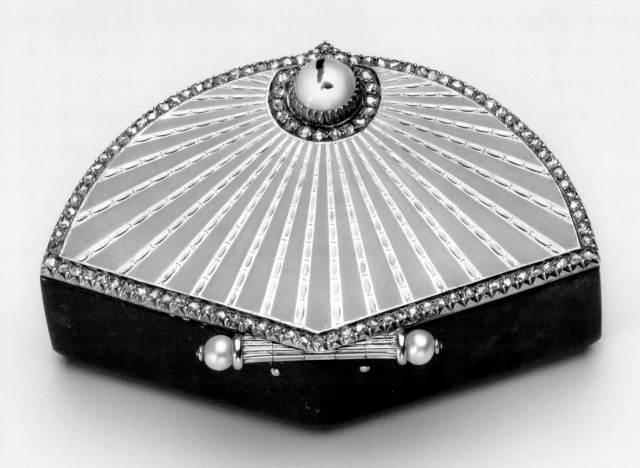

Cigarette case
Acquired *c.*1900

By the nineteenth century cigarettes were in widespread use and cigarette cases became increasingly fashionable. Fabergé perfected the art of producing cases that were ideal both to handle and use. From the simplest styles in plain wood to the most elaborate gold and enamelled versions, their concealed hinges, smooth edges and jewelled pushpieces made them the ultimate accessory in the late Victorian and Edwardian eras. This example is made of gold in a technique known as *samorodok* (gold nugget), where the plate metal is brought almost to melting point and then removed quickly from the furnace, causing rapid shrinking and a crumpled appearance. It was given to King George V by Queen Alexandra.

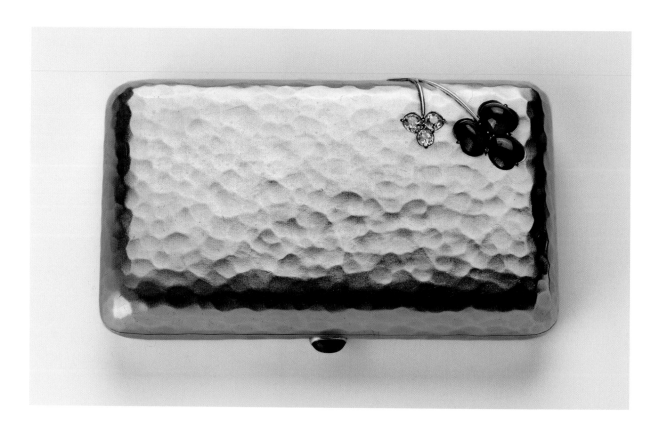

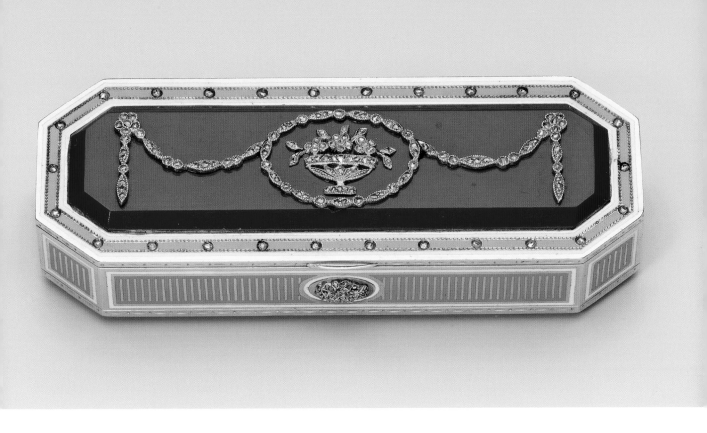

Box
Acquired 1934

This elegant gold box is applied with pale green enamel striped with gold.
The lid is set with a panel of jasper on which a vase of flowers encircled
by diamonds and with diamond swags is applied. The box was given to
Queen Mary by the royal family for her birthday on 26 May 1934.

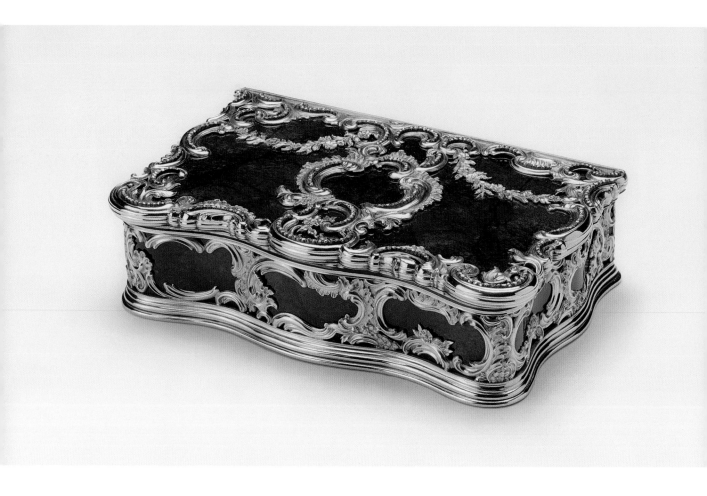

Box
Acquired 1920

The neo-rococo style of this box was very popular in St Petersburg in the 1880s. In 1891 Fabergé produced the Imperial Easter Egg known as the Memory of Azov Egg in the neo-rococo style and made, like this box, in a combination of bloodstone with gold mounts set with diamonds. The box was originally owned by Marie, Duchess of Saxe-Coburg-Gotha, whose daughters presented it to King George V in 1920.

Cigarette case
Acquired *c.*1930

This case was made in Henrik Wigström's workshop and is in a restrained Louis XVI style, typical of Wigström's output for Fabergé. The Fabergé firm was renowned for its enamelling and the broad range of colours and designs in which it was able to apply the technique. Dark blue was among the most prized and popular colours from the palette of 80 shades featured in a chart that hung in the workshops of the firm. The wave and polka dot pattern engraved into the gold of this case beneath the enamel (using a rose engine or *tour à guilloché*) enhances the richness of the colour. The case was acquired by Queen Mary before 1936.

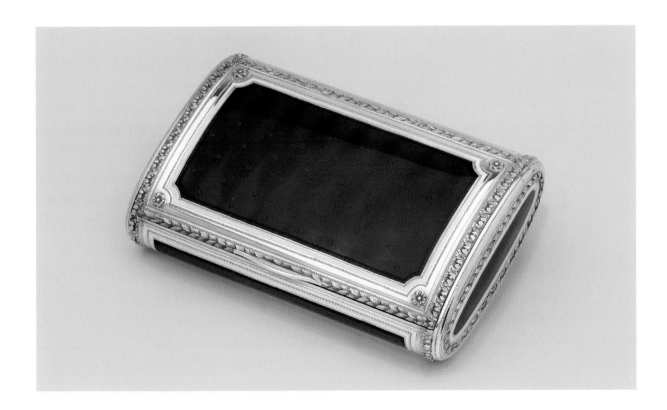

Imperial presentation box
Acquired 1937

The hierarchy of official gifts presented by the Tsar of Russia was strictly organised according to the intended recipient's ranking in society. The table of ranks had been established in 1722 during the reign of Peter the Great and continued to be used throughout Tsar Nicholas II's period of rule. Gifts given by the Tsar ranged from orders, decorations and medals to brooches, tie-pins and gold boxes, which had a long tradition as official presentation gifts.

The lid of this box, in yellow guilloché enamel in a sunburst design, displays the Romanov double-headed eagle in gold, enamel and diamonds. It was purchased by the Maharaja of Bikanir from Wartski on 15 May 1937 at a cost of £95 and given to Queen Mary for her birthday, 26 May, in the same year. The Maharaja, a friend of the Queen, shared her enthusiasm for Fabergé's work. On 30 May 1935 Queen Mary wrote in her diary: 'The Maharaja of Bikanir came to luncheon with me — we went to see the exn of all kinds of Russian things in Belgrave Square … — a very interesting exhibition.'[20]

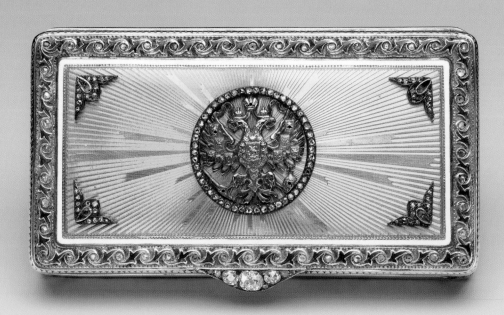

Box with a miniature of Peter the Great's Monument
Acquired 1934

This box is painted with a view of Etienne Falconet's monument in St Petersburg, completed in 1782, glorifying Peter the Great's absolutism. The miniature, which is designed to look like a cameo, was painted by Vassily Zuiev, a miniaturist employed by Fabergé, and is dated 1913, the year of the Romanov tercentenary. A design for a similar box appears in a design album from Henrik Wigström's workshop, where this box was made. The box belonged originally to Prince Vladimir Galitzine, from whom Queen Mary purchased it in September 1934 for £178. She gave the box to King George V for Christmas 1934.

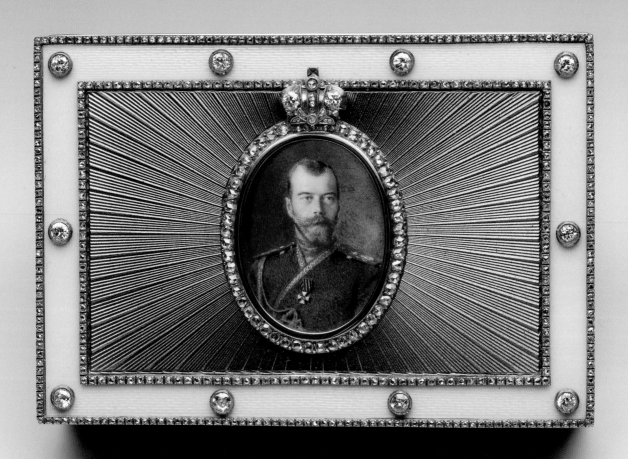

Imperial presentation box
Acquired 1934

Gem-set presentation boxes set with a miniature portrait of the Tsar or the imperial couple were presented as remuneration for service rendered or, in the case of foreign recipients, as a demonstration of good relations between the two nations. This box was one of the last imperial presentation boxes ever to have been given on behalf of the Tsar. It was made in Wigström's workshop, where it was completed on 30 September 1916. It is richly decorated in dark green guilloché enamel, the gold beneath the enamel engraved in a radiating sunburst design, edged with oyster-coloured enamel and richly set with ten brilliant-cut diamonds in circular mounts and two borders of rose-cut diamonds. In the centre of the lid is a miniature of Tsar Nicholas II by the court miniaturist Vassily Zuiev; the radiating guilloché enamel emanating from the miniature emphasises the status and power of the Tsar. Nicholas II wears the uniform of the 4th Imperial Family Rifle Guards and the Order of St George, which he received on 25 October 1915. The ledgers in the imperial cabinet archives reveal that the miniature was allocated on 5 May 1917, almost two months after the Tsar's abdication. The recipient was a member of the French Academy, Gabriel Hanotaux (1853–1944), to whom the box was presented by Grand Duke Nicholas (first cousin once removed of Nicholas II) on behalf of the Tsar. Hanotaux was Minister of Foreign Affairs between 1894 and 1898 under President Faure and developed the *rapprochement* between France and Russia. It is notable that, in spite of the political turmoil in Russia, this box managed to reach its intended recipient. Queen Mary acquired it and gave it to King George V on his birthday, 3 June 1934.

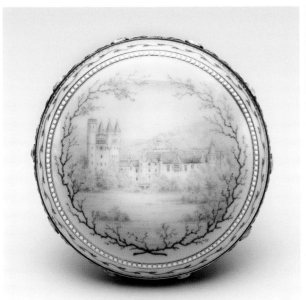
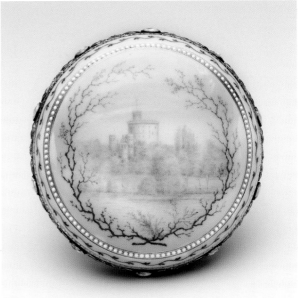

Bonbonnière
Acquired 1934

This box was given to Queen Mary for her birthday in 1934 by Sir Philip Sassoon. It had originally been purchased from the London branch by Sir Ernest Cassel on 4 November 1907 at a cost of £81 5s. According to Bainbridge, the Princess of Wales (later Queen Mary) much admired this first example of a box featuring a royal residence to return from St Petersburg to the London branch. The box has enamelled views of Balmoral Castle on one side and Windsor Castle on the other, and the edge of the box is set with enamelled roses and leaves interspersed with diamond-set crosses.

Box with a view of Stratford Church
Acquired 1934

Queen Mary purchased this box in 1934, according to the lists of bibelots that she compiled between 1920 and 1937. It had originally been purchased by Mrs Nanny Leeds, widow of William Bateman Leeds, the 'tinplate king' of Indiana and one of the most extravagant American customers of the London branch. The lid of the nephrite box is decorated with an enamelled view of the church of Holy Trinity at Stratford-upon-Avon. The pushpiece is a ruby flanked by diamond-set leaves.

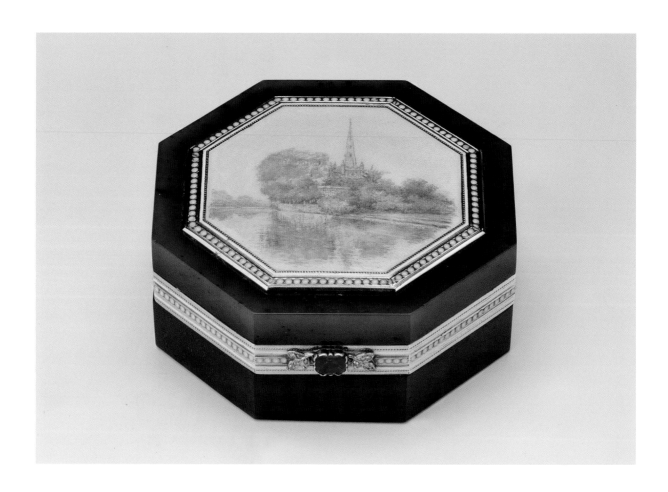

Coronation vase
Acquired 1911

This rock crystal vase was presented
to King George V and Queen Mary
on the day of their coronation,
22 June 1911. King George V's diary
records: 'Today was indeed a great and
memorable day & one which we can
never forget ... There were hundreds
of thousands of people who gave us a
magnificent reception.'[21] Such was the
warmth of the reception that the King
and Queen made a reappearance on
the balcony of Buckingham Palace at
10.30 in the evening. The vase is in the
Renaissance style, engraved with stylised
fire-bird creatures and inscribed with
the date of the coronation and the
royal arms. Polychrome enamel set with
cabochon rubies, sapphires and emeralds
are applied to the gold mounts. The
vase was already in stock in the London
branch when it was purchased, and it
was specially engraved for Leopold de
Rothschild, a connoisseur of Fabergé,
to present to the King and Queen, filled
with orchids grown in his hot houses
at Gunnersbury Park.

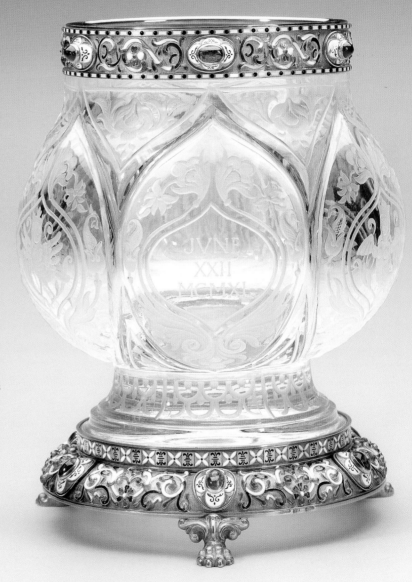

Desk seal
Acquired 1912

This seal was kept on King George V's desk at Buckingham Palace and is thought to be the one he purchased from the London branch on 28 October 1912 for £19. It consists of a handle of polished nephrite with red and yellow gold, diamond and ruby mounts in the form of a band, from which swags of leaves centred by a rose are suspended. The handle is mounted on a base of red and yellow gold in the form of an entwined dolphin. The gold matrix is engraved with the crowned cipher of the King.

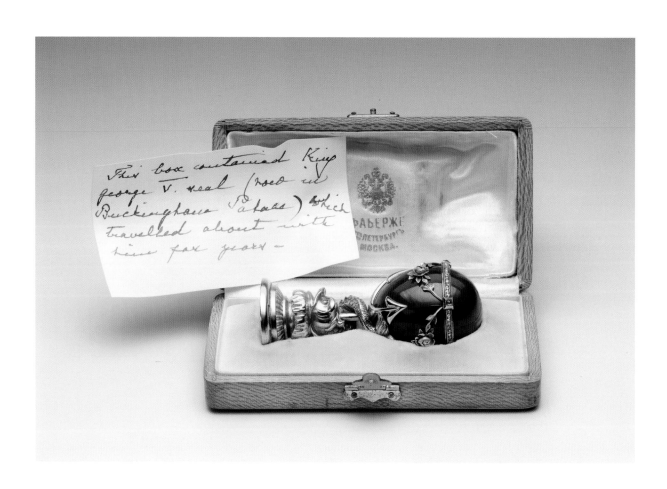

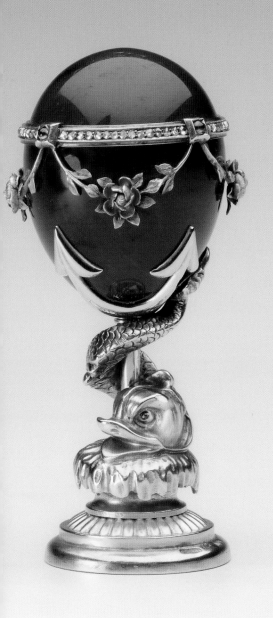

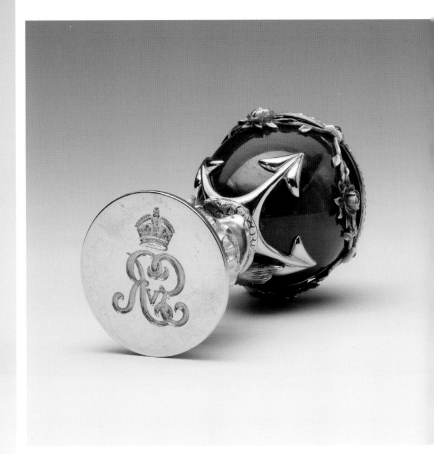

Cup
Acquired *c.*1920

This cup is made of a single piece of carved and polished banded agate. Its mounts are in the antique taste and are in the form of a bird's leg set with cabochon sapphires. The cup originally belonged to Princess Mary Adelaide, Duchess of Teck (1833–97), and was inherited by her daughter, later Queen Mary.

Cup
Acquired 1874

The hatched surface of this red and yellow gold cup imitates woven cloth and exemplifies the tradition in Russian metalwork of the 1860s and 1870s of using motifs from weaving and embroidery. The handle of the cup is mounted with a Catherine the Great rouble dated 1777 and four cabochon sapphires. It is one of the earliest pieces of Fabergé in the Royal Collection and was given to Prince George of Wales (later King George V) in 1874 by Marie, Duchess of Saxe-Coburg-Gotha. According to a note in Queen Mary's inventory, the cup always stood on King George V's dressing table and contained a pincushion.

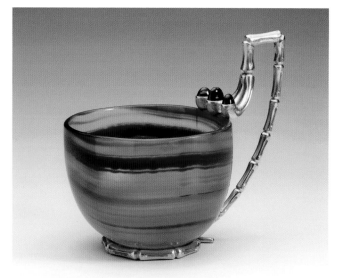
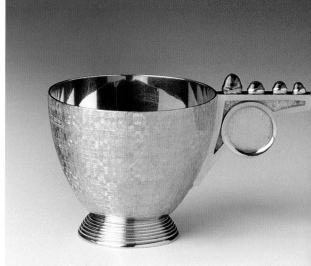

Snuff bottle
Acquired 1913

The Dowager Tsarina Maria Feodorovna presented this unusual Fabergé snuff bottle to Queen Mary for Christmas 1913, having purchased it from the London branch. Fabergé is well known for his eclectic designs and in this instance a Chinese carved agate snuff bottle has been re-mounted with an enamelled gold lid, decorated with oriental-style motifs and surmounted by a pearl.

Frame
Acquired *c.*1911

The photograph of King George V
is by Downey and dates from 1911.
It shows the King wearing the uniform
of Admiral of the Fleet and a great-
coat, and wearing the Order of the
Garter. Like most of Fabergé's frames,
the back is fitted with a panel of ivory
and a gold strut. The frame formed
part of Queen Mary's collection.

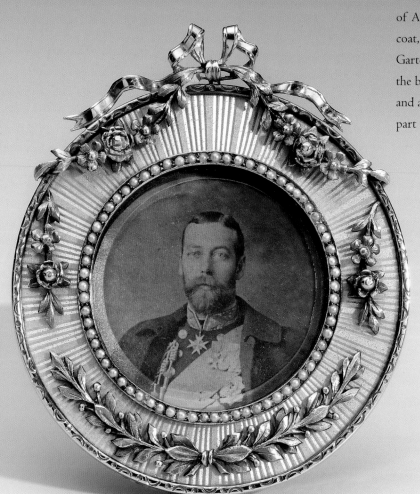

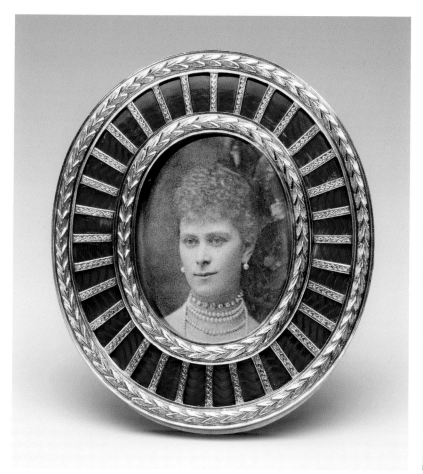

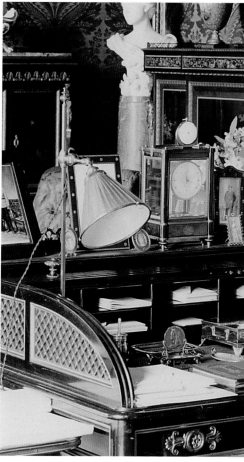

Frame
Acquired *c.*1897

A photograph of King George V's Audience Chamber at Buckingham Palace, in an album dated 1914, shows that this miniature frame with a photograph of Queen Mary was kept on the King's desk (see above, to left of clock). The frame contains a photograph taken in 1897 when she was Duchess of York. The frame is of yellow and red gold with laurel leaves around the bezel and the edge of the frame, containing a panel of red guilloché enamel. It is backed with ivory and fitted with a gold strut.

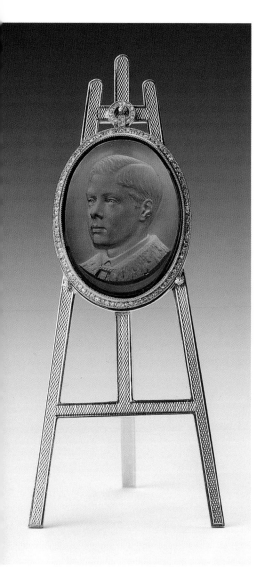

Cameo portrait
Acquired 1912

To mark the investiture of his eldest son as Prince of Wales (later King Edward VIII) on 13 July 1911, King George V commissioned this cameo portrait of him in the mantle worn on that occasion. He had been created Prince of Wales and Earl of Chester on his sixteenth birthday (23 June 1910) and his investiture took place at Caernarvon Castle – the first time a Prince of Wales had been invested in his own principality for at least three hundred years. The cameo is carved from smoky quartz and set in a gold and rose diamond bezel, suspended from a chased gold stand in the form of an easel. The cameo was made under the direction of Henrik Wigström and appears in the design album from his workshop. King George V purchased it from the London branch on 27 April 1912 for £67 10s and presented it to Queen Mary for her birthday the following month.

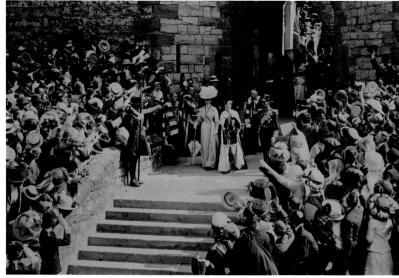

Right: The investiture of King Edward VIII as Prince of Wales, 1911.
RCIN 2303499

Frame
Acquired 1909

Fabergé was attracted to the rich
colour of rhodonite with its black
and grey veining; it was mined in the
Urals and used for this carved frame.
François Birbaum, his senior designer,
says that the stone (also known as
orletz) was second only to nephrite
in the firm's production. The frame
contains a watercolour portrait
miniature of Princess Mary
(1897–1965), the only daughter
of King George V and Queen Mary
who married Viscount Lascelles
(later the 6th Earl of Harewood)
in 1922. The portrait miniature was
painted in about 1906 and the frame
was purchased by the Prince of Wales
(later King George V) from the
London branch in December 1909
at a cost of £14 15s.

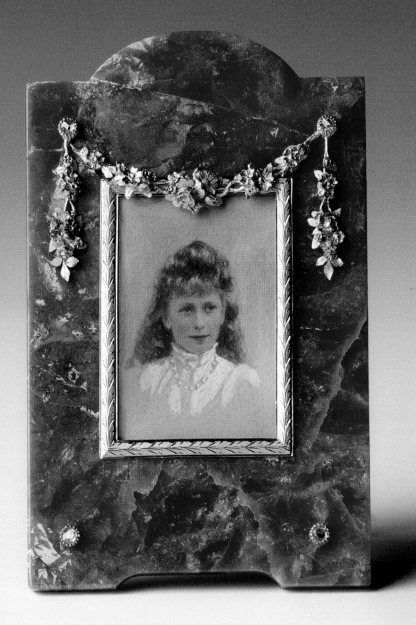

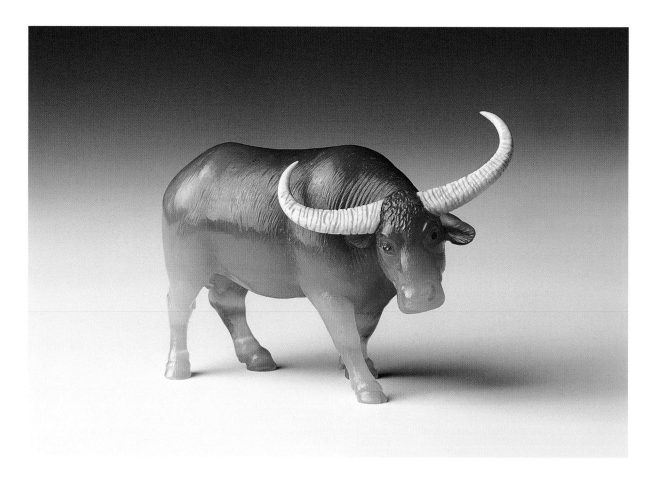

Water buffalo
Acquired 1913

The exceptional translucence of this piece of chalcedony has been perfectly utilised in this animal carving. Combined with ivory horns and cabochon ruby eyes, it is one of the most successful of Fabergé's animal sculptures. It was purchased by King George V from Fabergé's London branch in November 1913 at a cost of £41, together with the kangaroo and joey (see p. 106), a koala bear and a camel.

Wild boar
Acquired 1909

King George V purchased numerous
Fabergé animals, including this wild
boar that he bought in December
1909 (when Prince of Wales), for
£31. The pose is reminiscent of the
famous bronze boar in the Medici
collection in Florence, with which
Fabergé and his sculptors were likely
to have been familiar. The sculptor
Boris Frödman-Cluzel, who worked
for Fabergé, recalled how he saw a
statue of a wild boar in Geneva
during his training.

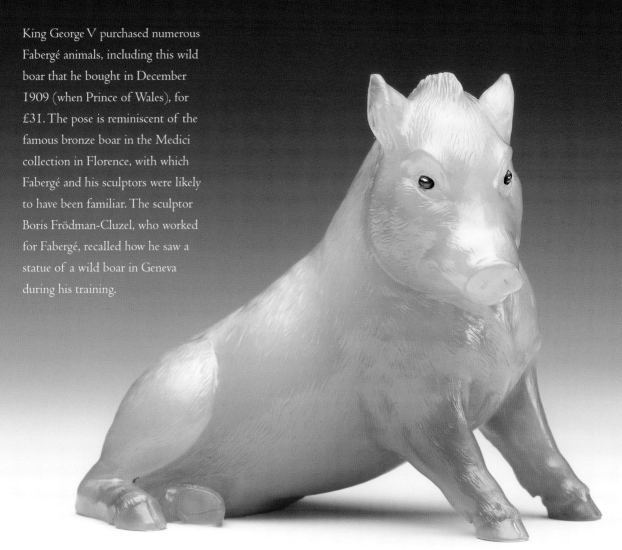

Kangaroo and joey
Acquired 1913

This humorous carving of a kangaroo and baby was bought by the King in November 1913 for £23. The extraordinary range of animals that Fabergé produced is testament to the sustained demand for these products from his clients. For this example, the sculptors have chosen to use Siberian nephrite rather than a more realistically coloured stone, however anatomically the carving is accurate.

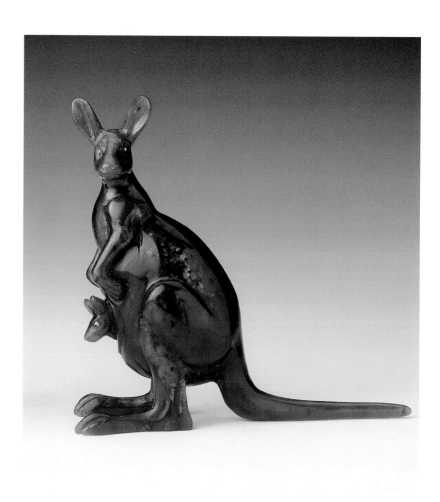

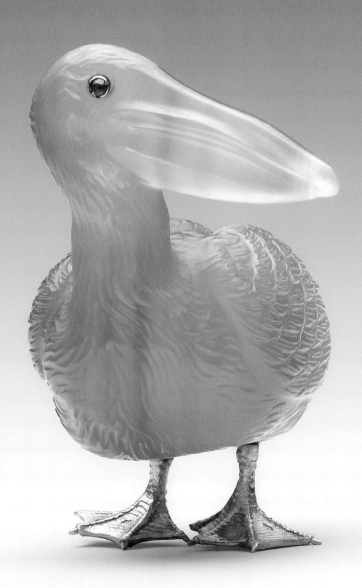

Pelican
Acquired 1915

The pelican – which symbolises self-sacrifice and maternal love – was a personal emblem of Tsarina Maria Feodorovna. Fabergé used the pelican as the theme for the Imperial Easter Egg made for her in 1898. He was particularly interested in ornithology and produced carvings of a huge variety of birds. This sculpture is set with ruby eyes and gold feet. A pelican was purchased for £20 by Grand Duke Michael from Fabergé's London branch in November 1915 and described as 'pelican Beloretzky quartz'; it is presumed to have been given as a Christmas present to King George V or Queen Mary. According to Birbaum's memoirs, Beloretz quartz was used regularly by Fabergé and was noted for its translucence and pink tinge.

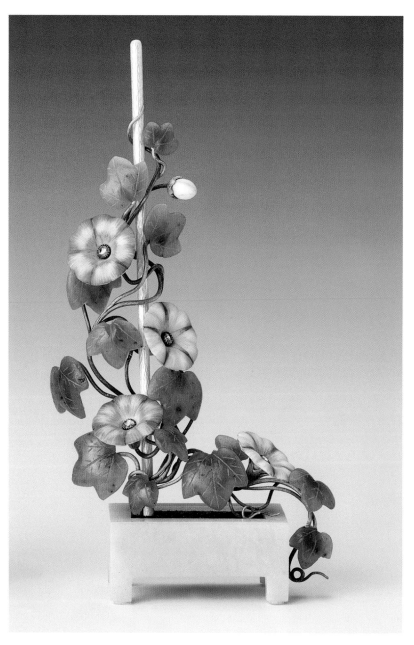

Convolvulus
Acquired 1949

King George V and Queen Mary
added further examples to the
remarkable collection of Fabergé
flowers formed by Queen Alexandra.
This study formerly belonged to Vita
Sackville-West (the Hon. Mrs Nicolson,
1892–1962), the doyenne of
twentieth-century English garden-
writers. The flowers are of enamelled
gold centred with rose diamonds,
while the leaves are of white nephrite.
The plant sits in a bowenite trough,
and when Queen Mary acquired it
was mounted on a further base of
white jade, since lost. The convolvulus
was purchased from the London
branch in 1908 for £35 by a member
of the Sackville-West family. It was
subsequently owned by Sir Bernard
Eckstein, sold at Sotheby's on
8 February 1949 and presented
to Queen Mary for her birthday on
26 May 1949 by the royal family.

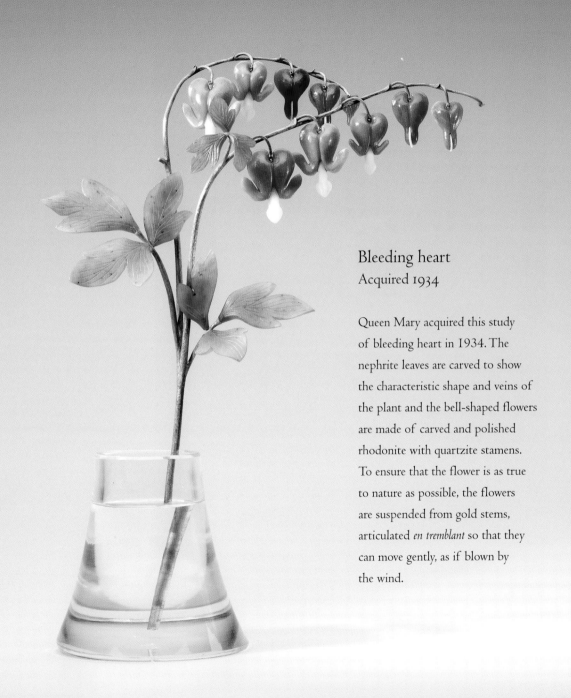

Bleeding heart
Acquired 1934

Queen Mary acquired this study
of bleeding heart in 1934. The
nephrite leaves are carved to show
the characteristic shape and veins of
the plant and the bell-shaped flowers
are made of carved and polished
rhodonite with quartzite stamens.
To ensure that the flower is as true
to nature as possible, the flowers
are suspended from gold stems,
articulated *en tremblant* so that they
can move gently, as if blown by
the wind.

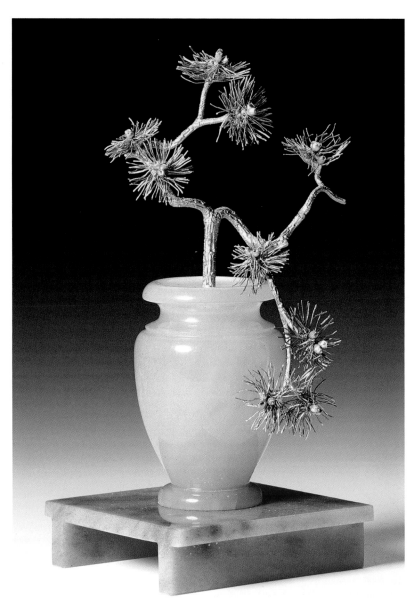

Pine tree
Acquired 1908

Fabergé produced a small number of studies of plants and flowers that are not displayed in rock crystal vases. This gold pine tree sits in a pot carved from bowenite on a platform of aventurine quartz. This botanical study is said to have been modelled from life at Sandringham, perhaps in 1907 when Fabergé's sculptors were in temporary residence on the estate working on King Edward VII's commission for animal portrait models. The Prince of Wales (later King George V) purchased this plant from the London branch on 14 December 1908 for £52.

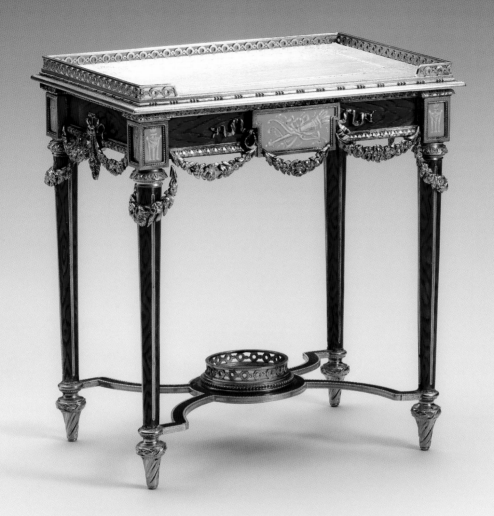

Miniature writing table
Acquired 1947

This table, one of two acquired by Queen Mary, shows Michael Perchin's clever use of gold and enamel. Red guilloché enamel replicates the grain of wood veneer and blue and white enamel imitates inset porcelain plaques. On the lid, mother-of-pearl replicates the writing surface and is engraved at the four corners with the Romanov double-headed eagle. Queen Mary purchased the table from Wartski on 22 November 1947 at a cost of £650.

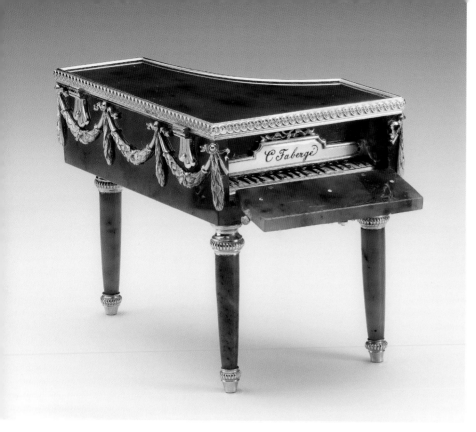

Piano in display case at the von Dervis exhibition, 1902.

Miniature grand piano
Acquired between 1922
and 1931

Judging by her acquisitions, Queen Mary was particularly fond of Fabergé's miniature *objets de fantasie,* which include several examples of miniature furniture in the form of bonbonnières. These objects afforded the craftsman the opportunity to demonstrate skill in applying specialist techniques to replicate the real materials of the full-scale object. This miniature piano of Siberian nephrite is carved and polished to resemble ebonised wood. The lid opens for use as a bonbonnière and the front drops down to reveal the keyboard in gold and enamel, inscribed *C. Fabergé.* The piano belonged originally to Tsarina Alexandra Feodorovna and can just be seen on the top shelf of one of the display cases in photographs of the exhibition of Fabergé held in St Petersburg in 1902. Queen Mary acquired it between 1922 and 1931.

Miniature terrestrial globe
Acquired 1928

This globe was made in the workshop
of Erik Kollin, Carl Fabergé's
first Head Workmaster. It was
purchased by Tsar Nicholas II on
31 December 1897 for 350 roubles
and was subsequently owned by
Prince Vladimir Galitzine, from
whom Queen Mary purchased it
on 16 December 1928. The rock
crystal globe is geographically correct
and swivels within its mounts.

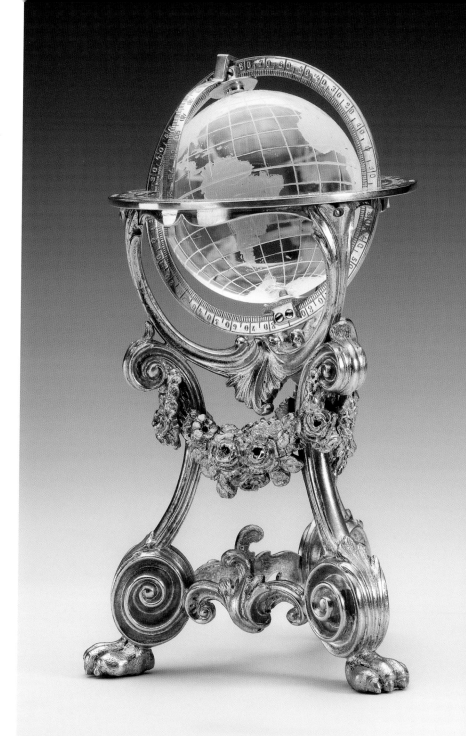

Elephant automaton
Acquired 1929

Fabergé produced a number of automata, often as the surprises within his Imperial Easter Eggs. In 1892 Tsar Alexander III presented Maria Feodorovna with the Diamond Trellis Egg, whose surprise was described as follows: 'ivory figure of an elephant, clockwork, with a small gold tower, partly enamelled and decorated with rose-cut diamonds, the tusks, trunk and harness are decorated with small rose-cut diamonds, and a black mahout is seated on its head.'[22] There are several similarities with this automaton although it is not the missing surprise. When the key-wound mechanism is released the elephant walks, swinging its head and trunk; the tail is also articulated. According to a note kept in the original silk-velvet lined Fabergé box made of holly wood, this elephant was presented to King George V by his family for Christmas in 1929.

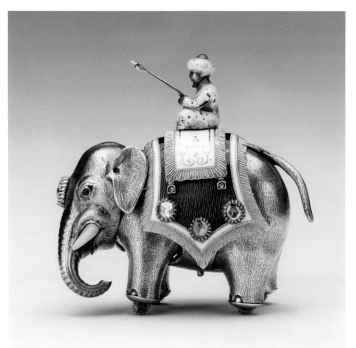
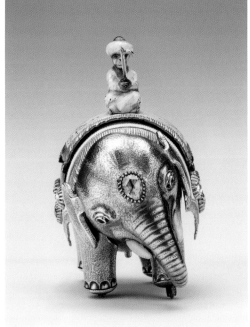

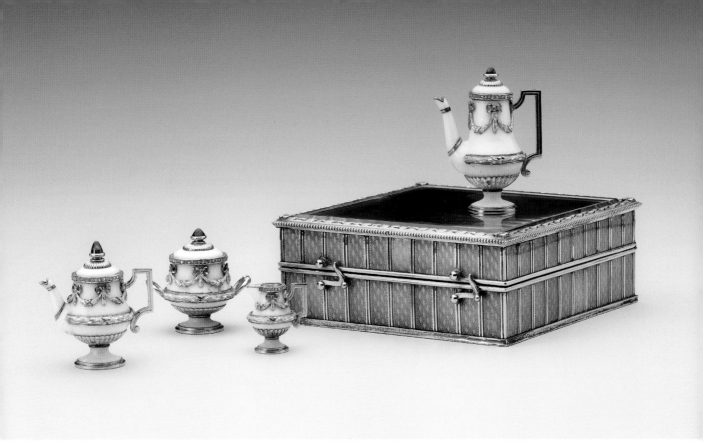

Miniature tea set
Acquired *c.*1900

Comprising a teapot, hot water pot, sugar bowl and milk jug, this tea set is of gold enamelled in a pale opaque bluish-white, but there is no engine turning on the metal. This deliberately plain enamelling creates the impression that the tea set is made of porcelain. The lids are each surmounted by a finial in the form of a cabochon ruby. The quality of the gemstones and the rich application of four-coloured gold decoration may indicate that this was an imperial commission. The box is of silver-gilt, applied with coloured gold and with guilloché enamel in mauve (the favourite colour of Tsarina Alexandra Feodorovna), and the lid is set with a panel of crystal. According to a note in Queen Mary's list of bibelots, the tea set originally belonged to Queen Alexandra.

King George VI and Queen Elizabeth

1895–1952 and 1900–2002

KING GEORGE VI inherited and regularly used the collection of Fabergé cigarette cases created by his father and grandfather, to which further examples were added during his reign. In 1949 he lent three examples to an exhibition at Wartski. According to Bainbridge, the former London branch manager, a year earlier the King, with Queen Elizabeth, received him at Buckingham Palace and gave him access to his collection for inclusion in Bainbridge's 1949 book. On this occasion the King apparently discussed the principles of displaying Fabergé objects to their best advantage, demonstrating a knowledge and appreciation of the subject perhaps inherited from Queen Mary. The King purchased some Fabergé pieces for Queen Elizabeth, including a miniature desk (p. 121).

Queen Elizabeth had a life-long interest in the works of Fabergé and acquired many examples between the 1940s and 1970s. Queen Mary jointly purchased with Queen Elizabeth a study of cornflowers and oats (p. 124), demonstrating their shared appreciation for these delicate and extraordinary works of art.

In many ways Queen Elizabeth's collection – which included bibelots, animals, flowers, large silver-mounted pieces and works in the traditional Russian style – was a distilled account of the diversity of Fabergé's oeuvre, revealing a wide-ranging understanding of the strengths of his craftsmanship and design. She also appreciated the significance of his work, a point which was recognised in 1977 when a special viewing of the exhibition *Fabergé* at the Victoria and Albert Museum was organised in her honour. She was shown the exhibition by the then Director, Dr Roy Strong, and the curator of the exhibition, Kenneth Snowman, proprietor of Wartski. In a letter of thanks to Dr Strong dated 22 June, Sir Alastair Aird, comptroller to Queen Elizabeth the Queen Mother, recalls: 'This unique display was superbly mounted, and although familiar with the work of Carl Fabergé, The Queen Mother was still amazed by the variety and scope of the work of this craftsman.'[23] Unlike Queen Mary, who mixed her pieces of Fabergé with other *objets de vertu* in a cabinet in her private apartments at Buckingham Palace, Queen Elizabeth dedicated a small display cabinet to her collection, which was

Queen Elizabeth's Fabergé display case
at Clarence House, *c*.1990.

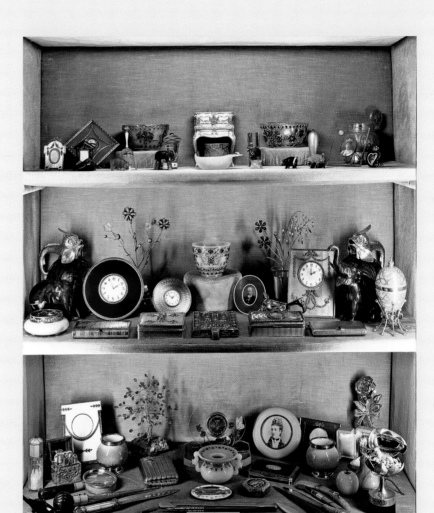

housed in the first-floor corridor at Clarence House. It is of interest to note that
both King George VI and Queen Elizabeth continued to use Fabergé pieces in
their possession – whether cigarette cases, frames, clocks, bell pushes, letter openers
or seals.

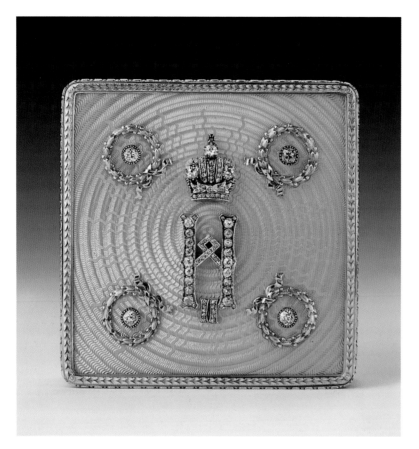

Imperial presentation box
Acquired 1944

During the reign of Tsar Nicholas II 280 Russian subjects and 90 foreign dignitaries received the gift of a presentation snuffbox with the Tsar's jewelled cipher. Fabergé was the pre-eminent Russian court supplier. The original recipient of this box is unknown. It is set with the Tsar's cipher in diamonds surmounted by the imperial crown, flanked by four brilliant diamonds contained within ribbon-tied laurel wreaths. The elaborate guilloché enamelling of sunrays and concentric circles emanates from the Tsar's cipher. Queen Elizabeth purchased the box in June 1944 for £475 from Wartski.

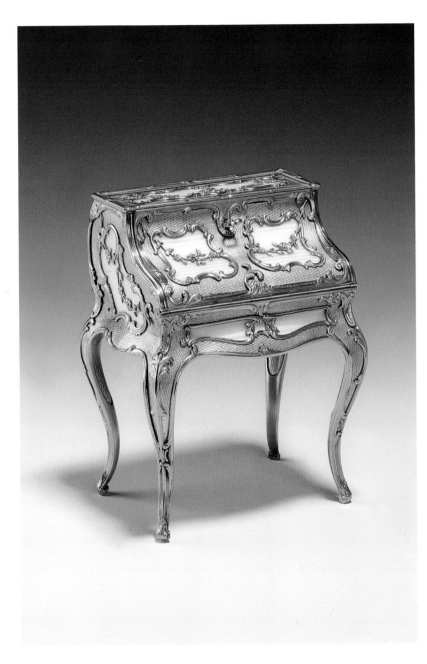

Miniature desk
Acquired 1946

Although the workmaster's mark on this piece is now illegible, the neo-rococo design is reminiscent of the objects produced in Perchin's workshop. The attention to detail is exemplified in the chased gold mounts and fine mauve and opalescent white guilloché enamel. A miniature gold key opens the drop front to reveal an interior lined with engraved mother-of-pearl and divided into miniature compartments. The desk was originally purchased from the London branch on 12 July 1909 by Leopold de Rothschild, a connoisseur of Fabergé and friend of King Edward VII. The purchase price was high – £150 15s – reflecting the complexity of the desk's production. The desk formed part of Queen Elizabeth's collection for many years, having been purchased by King George VI from the firm of Wartski for £375 on 2 February 1946.

Cornflowers and buttercups
Acquired 1947

One of Fabergé's most exquisite flower studies, this combines deep blue enamelled cornflowers with glossy guilloché enamelled yellow buttercups, one adorned by a jewelled honey bee, which has settled on a petal and is set with alternate stripes of black enamel and rows of rose-cut diamonds, complete with ruby eyes. It was originally owned by one of the Russian Tsarinas, either Maria Feodorovna or Alexandra Feodorovna, as it was included in the 1902 exhibition at the von Dervis mansion in St Petersburg, which displayed Fabergé, miniatures and other works of art from their personal collections. Photographs of the exhibition show the flower in one of the ornate vitrines on the same shelf as the Basket of Flowers Imperial Easter Egg, purchased for the Royal Collection by King George V and Queen Mary. This flower was purchased by Queen Elizabeth from Wartski on 2 February 1947 for £375.

Display cases in the von Dervis exhibition, 1902.

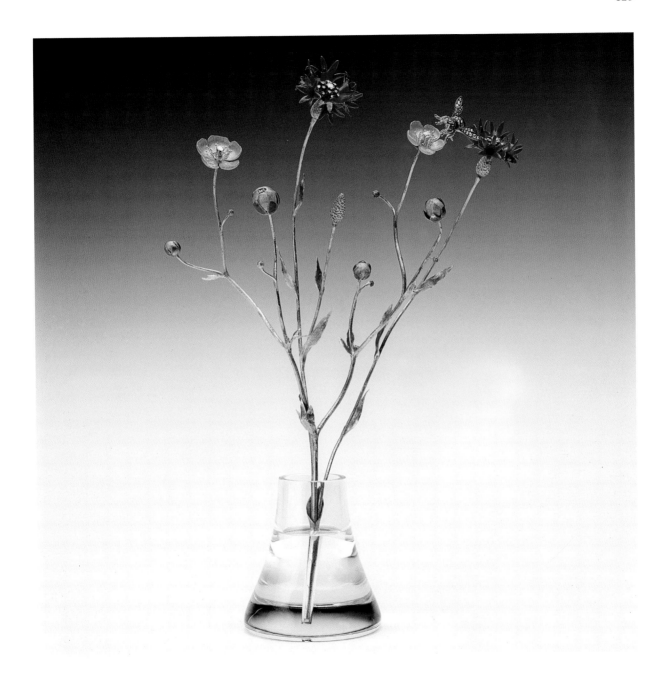

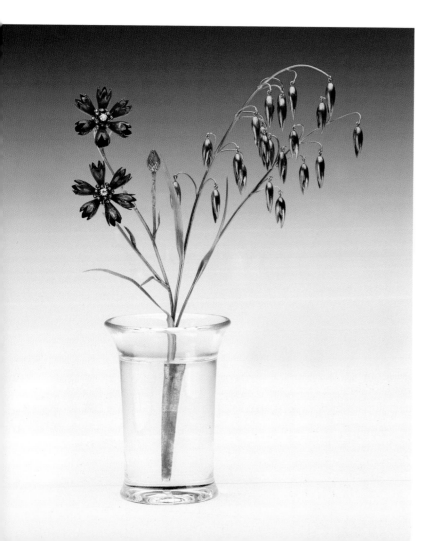

Cornflowers and oats
Acquired 1944

Queen Elizabeth added two of Fabergé's flowers to her collection of the maker's works. The combination of cornflower and oats was clearly popular as several examples by Fabergé are known. The ledgers of the London branch reveal that in November 1909 Albert Stopford purchased 'Cornflower, blue en, I ear of oats in gold, rock crystal vase' for £39 10s. Albert Stopford witnessed the decline and fall of the Romanov dynasty at first hand in Russia and recorded the events in his book *The Russian Diary of an Englishman, Petrograd 1915–17*.

Queen Elizabeth's flower was purchased on 27 June 1944 for £145 from Wartski. Queen Mary contributed to the purchase of 'a pretty Fabergé cornflower' for Queen Elizabeth's birthday which she placed in her shelter room at Buckingham Palace. Queen Elizabeth was delighted with the piece and described it as 'a charming thing and so beautifully unwarlike'.[24] The cornflowers are realistically rendered in rich blue enamel, the flower centres set with rose-cut diamonds and the husks of the oats are carefully modelled in engraved yellow gold and suspended from small rings, allowing them to move *en tremblant*.

Parasol handle
Acquired 1947

Fabergé made cane and parasol handles of all forms, sometimes of hardstone but more often enamelled and gem-set. Parasol and cane handles were purchased by successive generations of the royal family including King Edward VII, Queen Alexandra and Queen Mary who regularly used a gem-set yellow enamelled example. This cane handle is one of three that Queen Elizabeth purchased from Wartski in January 1947 for £75. The handle of gold is of oyster-coloured enamel and set with rose diamonds and cabochon sapphires. It terminates in a band of seed pearls.

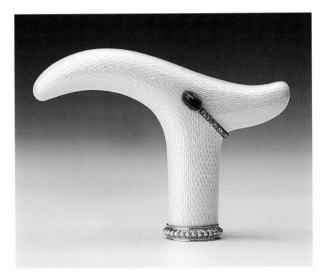

Imperial presentation box
Acquired 1946

In January 1946 Queen Elizabeth purchased from Wartski one of the most elegant of the imperial presentation boxes, in terms of design and the extraordinary effect of the colour and depth of the guilloché enamel. Emmanuel Snowman, proprietor of the firm, wrote to the Queen in August 1946: 'I would just like to add how delighted I am that the beautiful mauve enamel Fabergé box has gone into your Majesty's collection, I think it is one of the finest specimens I have ever seen.'[25] The working drawing for the box, produced in the workshop of Henrik Wigström, reveals it was originally set with the diamond cipher of the Tsar. Once the box was selected for presentation to the intended recipient – in this case Artur Germanovich Rafalovich, a privy counsellor and member of the finance council in Russia – the central plaque was exchanged for the sovereign's portrait miniature. It was presented to

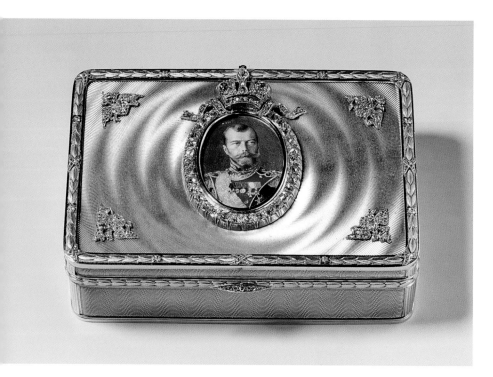

Rafalovich by Tsar Nicholas II in 1915. The portrait was painted by Vassily Zuiev, and shows the Tsar wearing the uniform of the Preobrazhensky Regiment and the Russian Orders of St Andrew and St Vladimir and the Danish Order of the Dannebrog, among other medals. The original cost price of boxes of this type could range as high as 4,000 roubles, depending on the material used, the precious stones mounted on it and the weight of the gold. Design and workmanship counted for less as labour costs were very low.

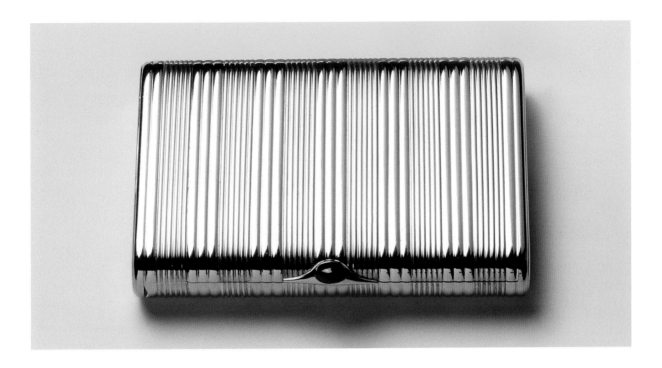

Cigarette case
Acquired 1949

King George VI formed a significant collection of cigarette cases, many produced by Fabergé. Some had been inherited from his father, King George V. This case is typical of Fabergé's work and was acquired by the Queen on 7 April 1949 for £120. The design of ribbed two-colour gold with a double opening and cabochon sapphire pushpiece, is the epitome of Edwardian elegance. The modern version of the snuffbox became a fashionable addition to a gentleman's accoutrements of the period and consequently an important article for goldsmiths to produce.

Box
Acquired 1979

The scene on this polygonal box in cloisonné enamel depicts an episode from the Tale of Tsar Sultan from a poem by Alexander Pushkin (1799–1837), and depicts the walled city that miraculously appeared to Tsar Sultan's wife and his son, Prince Gvidon. The box was given to Queen Elizabeth by the firm of Wartski in May 1979 as an early 80th birthday present. It was made by Fabergé's chief enamellist in the Russian style, Feodor Rückert, who worked in Moscow.

Kovsh
Acquired *c.*1970

The kovsh, a traditional Russian drinking vessel, was originally used to scoop ale or mead from a barrel but evolved into a purely decorative object in the late nineteenth century. This example is enamelled *en plein* with a scene from the Zaporozhye Cossacks, after the painting by Ilya Repin (1844–1930). It was made in the Moscow workshop of Feodor Rückert. The enamelling over the body and high-hooked handle is in brighter colours than the habitual muted blues, greens, browns and greys that are associated with this revivalist style. Queen Elizabeth owned a number of pieces made by Fabergé in this style but the precise date of its acquisition is unknown. Its English hallmarks indicate that it was originally sold through the London branch.

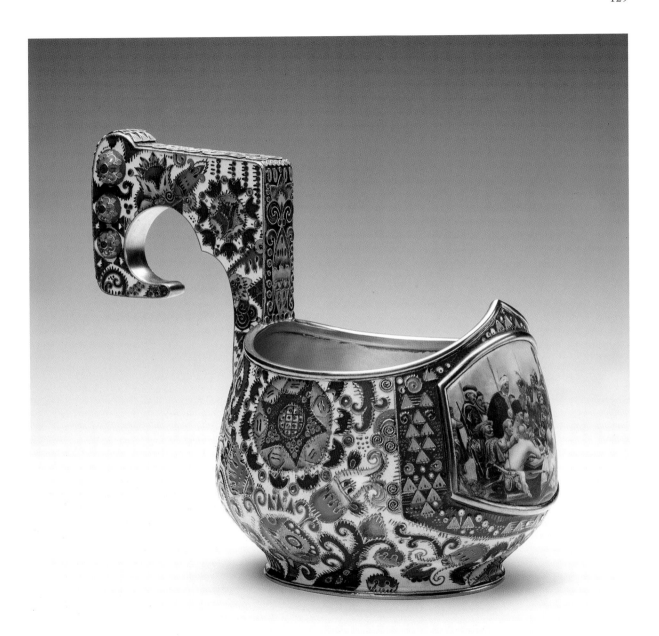

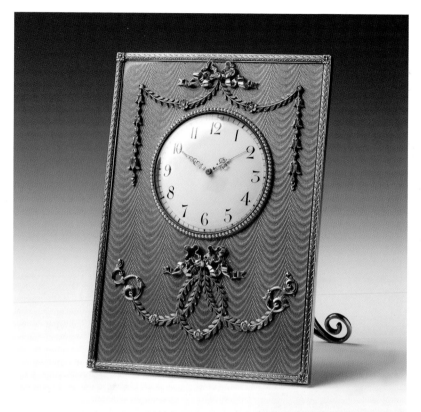

Desk clock
Acquired before 1953

Clocks in gold, enamelled and
applied with coloured gold decoration
and strut supports, were produced
by Fabergé in large quantities.
A design for a similar clock appears
in an album from Henrik Wigström's
workshop, where this clock was
made. Queen Elizabeth owned several
Fabergé clocks and this example was
in her collection before 1953.

Frame
Acquired 1937

This frame was a coronation present to Queen Elizabeth from the Maharaja
of Nawangar in 1937 and contains a photograph of the Queen by Dorothy
Wilding taken in the same year. Fabergé made a large number of objects in
Russian native woods including frames and cigarette cases, usually fitted with
gold mounts and set with gemstones. The outer wooden surround of plane
wood (known in Russia as *tchinara*) contains an inner frame of pale blue moiré
guilloché enamel with a circular plaque of peach-coloured guilloché enamel
above and silver-gilt mounts. The frame was made in the workshop of
Anders Nevalainen.

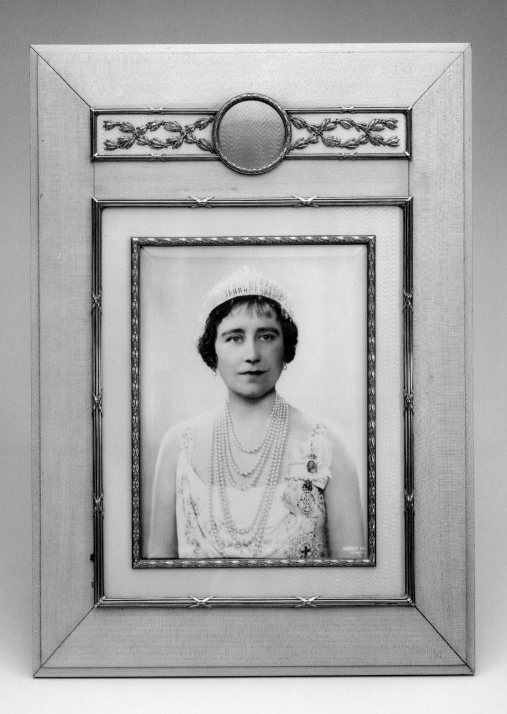

The Queen and
The Duke of Edinburgh

b. 1926 and 1921

Previous page: The Queen in Buckingham Palace at Christmas 2001.

THE ROYAL FAMILY'S interest in Fabergé has been continued by Queen Elizabeth II. In 1932 Queen Mary gave her granddaughter, Princess Elizabeth, a Fabergé fan which had originally belonged to Queen Alexandra. In 1947 a rock crystal inkwell was given by Baroness Sophie Buxhoeveden (p. 138) on the occasion of the marriage of Princess Elizabeth to Lieutenant Philip Mountbatten in November 1947. Many members of the family of Prince Philip, Duke of Edinburgh, were owners of works by Fabergé and the Duke of Edinburgh himself owns several pieces, including a frame and a clock (p. 141) given at the time of his marriage. In 1965 he inherited an enamelled star-shaped clock from his aunt, Queen Louise of Sweden (p. 142).

The most notable contribution of The Queen has been to make the collection – the most important collection of Fabergé in existence – accessible to the general public through exhibitions held at The Queen's Galleries, through loans to exhibitions held all over the world, and through articles, books and catalogues.

In 1967, at the height of the Cold War, a large number of pieces were lent from the collection to an exhibition entitled *Great Britain USSR* at the Victoria and Albert Museum. Ten years later, to mark The Queen's Silver Jubilee, an exhibition devoted to Fabergé, the first of its kind ever held, was curated by Kenneth Snowman of Wartski and held at the Victoria and Albert Museum. On that occasion The Queen lent 286 pieces from the Fabergé collection to what became the most successful exhibition ever held at the museum. On 27 July 1977 Roy Strong, the director of the museum, wrote to The Queen to ask whether it would be possible to extend the loan for a further month: 'Your Majesty will know, I am sure, how immensely popular the exhibition of Fabergé's work is proving to be. Every day, queues form from about 9 o'clock and people are waiting for two hours or more … we have had to organise late openings, special early morning and even special evening viewings.'[26] Although commonplace during popular exhibitions today, special openings of this kind were then rare, indicating the unprecedented popularity of the exhibition. Permission was granted and a further 40,000 visitors

saw the exhibition in its final month. This was the first major survey of Carl Fabergé's work and provided the opportunity for visitors to see an exhibition that Strong described as 'something no other country could mount' – largely owing to the size of the loan from the Royal Collection. Major loans to virtually every scholarly museum exhibition organised since have been generously made and have contributed to scholarship on the subject, which has advanced dramatically since the end of the Cold War and the increased accessibility and awareness of surviving documentation in Russia and elsewhere.

Three major exhibitions drawn from the collection have been held at The Queen's Galleries. In 1985 and 1995 around four hundred to five hundred pieces were displayed in exhibitions that attracted huge audiences. In 2003–04 an exhibition of over 350 pieces was held at the new Queen's Gallery in Edinburgh, and in London.

Detail of the clock inherited by the Duke of Edinburgh from his aunt, Queen Louise of Sweden.

Fan
Acquired 1904

The cream silk leaf is embroidered
with two colours of gold sequins
in a repeated design of flowers and
foliage. The guards are of engraved
mother-of-pearl and the suspension
ring is set with rose diamonds.
A gold arrow set with rose diamonds
and gold swags of laurel with
cabochon ruby 'berries' is applied
to the handle of oyster guilloché
enamel. The fan was given to
The Queen when Princess Elizabeth
of York, by Queen Mary in 1932.
It had been a Christmas present
from the Dowager Tsarina Maria
Feodorovna to her sister, Queen
Alexandra, in 1904, and the original
purchase price was 325 roubles.

Inkwell
Acquired 1947

On the occasion of their wedding on 20 November 1947, The Queen (then Princess Elizabeth) and the Duke of Edinburgh received two presents of works by Fabergé, including this rock crystal inkwell from Baroness Sophie Buxhoeveden. She had been Tsarina Alexandra's favourite lady-in-waiting. After her escape from Russia, she eventually came to live in London, in a Grace and Favour apartment at Kensington Palace, and served unofficially as the Dowager Marchioness of Milford Haven's lady-in-waiting. The lid of the inkwell is set with a Catherine the Great rouble dated 1722 and enamelled in red with gadrooned silver mounts.

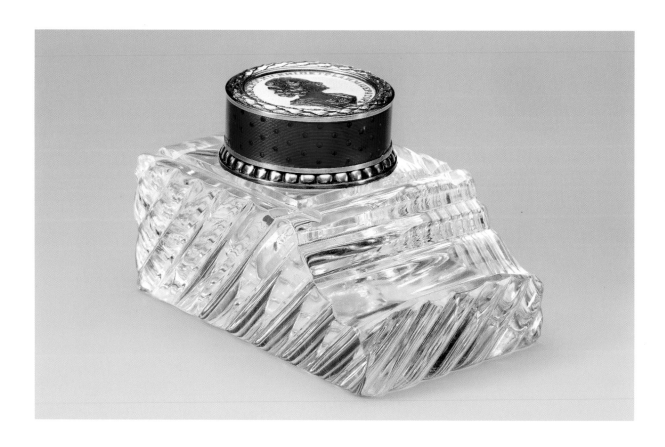

Clock
Acquired 1959

In March 1959 The Queen purchased this clock from Wartski for £430. The clock was made in the workshop of Henrik Wigström and is of Prussian blue guilloché enamel with silver mounts, and the bezel is set with seed pearls. The movement was supplied by H. Moser & Cie.

Woodcock
Acquired in the 1950s

The production of objects in silver, both decorative and functional, formed a large part of Fabergé's output and a lucrative source of income. Such objects ranged from grand *surtouts de table* (originally used for holding condiments or sweets), dinner services and flatware to more decorative objects. A silver woodcock, similar to this one, is in the State Hermitage collection. In this example, the seated woodcock is naturalistically chased and mounted on a block of marble to form a paperweight. The woodcock forms part of the Duke of Edinburgh's collection.

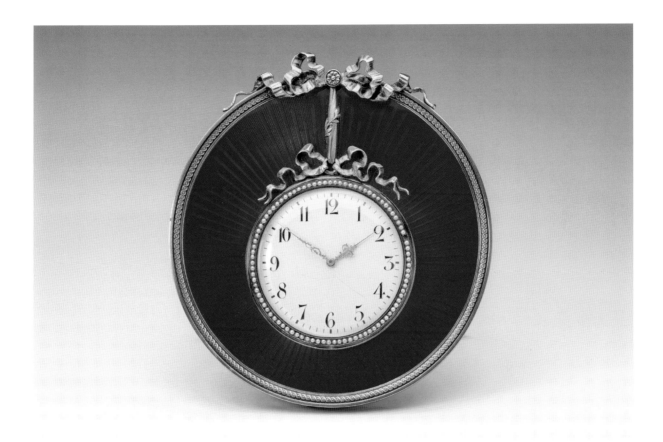

Clock
Acquired *c.*1947

Of circular form and guilloché enamelled in blue, the dial of this clock, asymmetrically placed within the frame, appears to be suspended from a bow, which itself is suspended from a bow surmounting the top of the clock. As on the majority of Fabergé's clocks, the dial is plain white with clear numerals – designed to be practical and easy to see. It is decorated with a bezel of seed pearls. It was made in the workshop of Victor Aarne, a workmaster of Finnish origin. It was acquired by the Duke of Edinburgh at the time of his marriage.

Clock
Acquired 1965

The Duke of Edinburgh inherited this clock from his aunt, Queen Louise of Sweden, following her death in 1965. Queen Louise had been given the clock by the Duke of Edinburgh's grandmother Queen Olga of Greece (born Grand Duchess Olga Constantine of Russia). The star-shaped clock is enamelled with alternate panels of apricot and opalescent white guilloché enamel and mounted with red and yellow gold. The bezel of the clock is set at intervals with rose diamonds. The clock was made in the workshop of Michael Perchin.

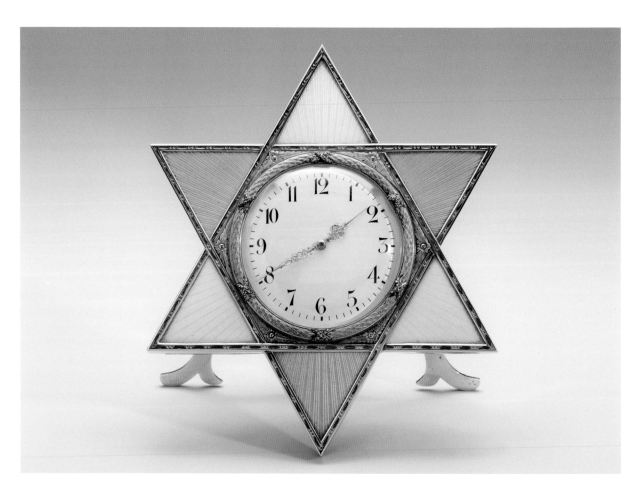

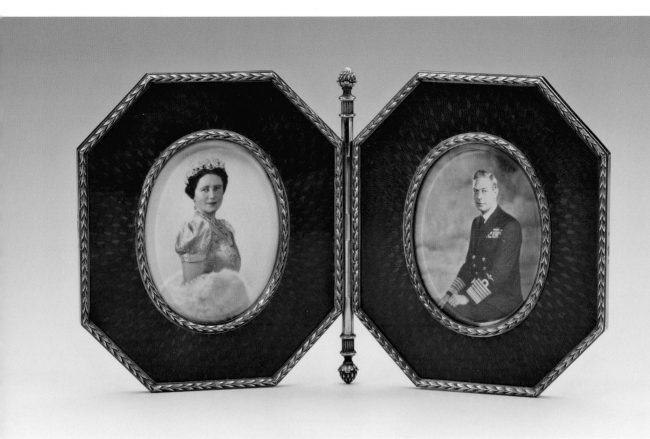

Double frame
Acquired *c.*1947

This frame, in one of Fabergé's most successful and popular shades of blue, is enamelled in guilloché in a basket-weave pattern. The hinge is chased with an acorn at both ends and the mounts of gold are decorated with a laurel leaf border. The frame contains portraits of King George VI and Queen Elizabeth taken by Dorothy Wilding in 1946, in advance of the tour of southern Africa undertaken by the King and Queen with their daughters in 1947. The frame was given to the Duke of Edinburgh by King George VI and Queen Elizabeth in 1947.

The Prince of Wales

b. 1948

HIS ROYAL HIGHNESS THE PRINCE OF WALES continues the royal tradition of interest in the work of the Fabergé firm. He owns a number of pieces, including the amusing desk seal (p. 148) in the form of a frog. His appreciation of Fabergé's work suggests he has inherited his grandmother Queen Elizabeth's admiration for the enamelled and jewelled decorative pieces produced by the firm, while continuing to be surrounded by – and to use – pieces at Clarence House, his official London residence and the former home of Queen Elizabeth.

As chairman of the Royal Collection Trust, the charity responsible for the care, conservation and access to the Royal Collection, His Royal Highness supports the work of the collection to bring the masterpieces by Fabergé to a wider audience, through exhibitions, publications and lectures and via the worldwide web.

In 2006 the Princess Irina Bagration-Mukhransky, whose husband was descended from Tsar Nicholas I, made a bequest to the Prince of Wales for the Royal Collection of several important mementoes from her collection, including some pieces of Fabergé which are published here for the first time.

Frame
Acquired before 1953

Queen Elizabeth originally purchased this frame from Wartski and placed inside it a photograph of the Prince of Wales as a young child, dating from approximately 1955. The frame is of bowenite, the pale green translucent stone often used by Fabergé. The designer Birbaum recalls in his memoirs that the stone had a 'marvellous green grape colour'. This frame is mounted with the usual gold strut and gold mounts, to which white and red enamel is applied, and the bowenite is mounted with foliate swags held by ribbons in yellow and red gold. The frame continues to be displayed at Clarence House.

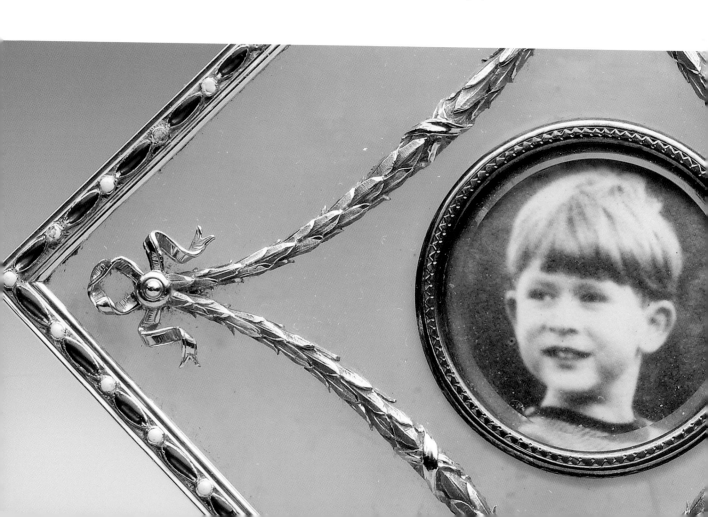

Desk seal
Acquired 1981

This amusing seal, formed of a gold column enamelled with pink moiré guilloché, is surmounted by a frog carved from Siberian nephrite which forms the handle. A similar version of this seal exists in the Matilda Geddings Gray Collection at New Orleans Museum of Art. Recently a possible source for this design was identified as a bronze statuette by the animal sculptor Emmanuel Frémiet (1824–1910). The seal was given to the Prince of Wales as a wedding present in 1981.

Seal
Acquired 2006

This seal was also presented as part of the same bequest by Princess Bagration-Mukhransky. The handle of the seal is of carved and polished bowenite and is attached to a gold column enamelled in pink moiré guilloché. The matrix is engraved with the Bagration arms. The seal is still contained in its original silk and velvet-lined fitted box.

Letter opener
Acquired 2006

This letter opener is in the form of a miniature silver oar engraved with the monogram of Queen Olga of Greece (1851–1926), daughter of Grand Duke Constantine of Russia. The oar commemorates a regatta held at Sestrovik from 18–19 June 1901. The handle of the oar is inscribed with the names of competitors who took part in the regatta. The oar was presented to the Prince of Wales for the Royal Collection by the Princess Irina Bagration-Mukhransky in 2006.

Endnotes

1 RA PPTO/PP/QV/QVACC/LED1895/
 1137
2 RA PPTO/PP/QV/QVACC/PRIV/LED/
 1898
3 RA VIC/Journal 21 June 1897
4 RA VIC/Journal 22 September 1896
5 RA VIC/Journal 30 September 1896
6 RA VIC/Journal 1 November 1894
7 RA GV/PRIV/GVD 1 December 1894
8 RA GV/PRIV/AA33/17
9 Bainbridge *Peter Carl Fabergé; His Life and Work
 1846–1920*, 1949, p. 98
10 RA GV/PRIV/GVD 19 November 1894
11 RA/QV/Journal 24 December 1896
12 Bainbridge, op.cit., p. 101
13 RA/VIC/MAIN/X/22/44
14 RA/VIC/Journal 1 July 1873
15 RA VIC/Journal 30 November 1894
16 RA GV/PRIV/GVD 3 May 1903
17 Bainbridge, op.cit., p. 28
18 RA/GV/PRIV/GVD 4 June 1911
19 Bainbridge, op.cit., p. 109
20 RA/QM/PRIV/QMD 1935
21 RA/GV/PRIV/GVD 1911
22 RA/GV/CCI3/93 and 97
23 Fabergé, Proler, Skurlov, *The Fabergé Imperial
 Easter Eggs*, 1997, p. 109
24 RA QMH/PRIV/CC13/97
25 RA QEQM/PRIV/WOA
26 RA/PS/PSO/QEII/12/8/0/07/07/1977/
 V&A *Fabergé* exhibition

Glossary

Gold is measured in 56 and 72 *zolotniks*, the equivalent to 14 and 18 carats.

Silver is measured in 84, 88 and 91 *zolotniks*, the equivalent to 21, 22 and 22¾ carats.

Agate: A form of chalcedony in which iron oxide causes varying shades of brown

Aventurine quartz: A quartz containing mica, iron oxides or pyrite crystals which give it a range of colours

Bowenite: A pale green serpentine named after its discoverer, G.T. Bowen

Cabochon: Dome-shaped unfaceted stone

Chalcedony: A fine-grained mineral of silicic acid, usually of a white or milky hue

Coloured gold: Achieved by the eighteenth-century technique of dyeing gold with other metals:
 yellow = gold in its purest form
 red = mixed with copper
 green = mixed with silver
 white = mixed with nickel or palladium

Diamond:
 brilliant: Circular-cut diamond with a flat top
 portrait: A thin diamond cut with two large, flat, parallel surfaces, so that a viewer can see through it to an object beneath
 rose: Diamond with the top cut into triangular facets

Enamel: A glass capable of being fused to metal.
 cloisonné: Enamel technique in which a design is drawn with strips of wire or *cloisons* which are shaped to form a network of cells. The cells are then filled with enamels
 en camaieu: A delicate form of grisaille enamel painting, seen particularly in the decoration of snuffboxes
 en grisaille: Monochrome or toned grey effects produced by fusing white enamel over a dark ground

 guilloché: Translucent enamel is fused over a geometric pattern incised into gold or silver by engine-turning
 plique-à-jour: Technique in which translucent or opalescent enamel is fused across a network of cells with no backing under the glazed areas

Jasper: An opaque chalcedony ranging from brown to green in colour

Moonstone: A blue variety of icespar

Mother-of-pearl: The strongly iridescent inner layer of shells

Nephrite: A dark green jade found in Siberia

Netsuke: Japanese toggle used to fasten *inros* (boxes) to belts

Obsidian: A dark grey or black volcanic glass found in Siberia

Purpurine: A dark red, man-made, vitreous substance first produced in the seventeenth century and introduced to Russia by the Imperial Glass Factory. Reinvented by Fabergé and his contemporaries

Quartzite: A form of quartz

Rhodonite: A pink manganese silicate with black inclusions, found in the Urals

Rock crystal: The purest form of quartz, found in the Ukraine and the Urals

Samorodok: Gold or silver heated to just below melting point then cooled rapidly, giving a nugget-like finish

Topaz: An aluminium silicate ranging in colour from pale blue to yellow, orange, brown and pink

Royal Fabergé Catalogue

All measurements in centimetres
All pieces made in St Petersburg unless otherwise stated

Queen Victoria

p. 10 Notebook case
RCIN 4819
1.8 × 16.2 × 12.6
Mark of Victor Aarne; silver mark
of 88 zolotniks (before 1896);
FABERGÉ in Cyrillic characters

p. 15 Desk clock
RCIN 40100
11.6 × 12.5 × 9.9
Mark of Michael Perchin; silver mark
of 88 zolotniks (1896–1908)

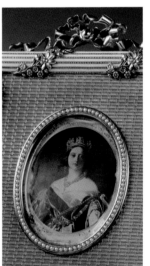

King Edward VII and Queen Alexandra

p. 22 Cigarette case
RCIN 4344
1.4 × 9.4 × 6.8
Moscow gold mark of 56 zolotniks
(1896–1908); *FABERGÉ* in Cyrillic
characters

p. 23 Cigarette case
RCIN 40113
1.7 × 9.6 × 7
Moscow gold mark of 56 zolotniks
(1896–1908)

p. 24 Box with a view of
the Houses of Parliament
RCIN 40498
3.8 × 13.4 × 9
Mark of Henrik Wigström; gold
mark of 56 zolotniks (1908–17);
FABERGÉ in Cyrillic characters

p. 25 Frame with a photograph
of Queen Alexandra
RCIN 9215
12.9 × 9 × 0.7
Mark of Anders Nevalainen; silver
mark of 88 zolotniks (1896–1908)

p. 26 Frame with a photograph
of Persimmon
RCIN 15168
12 × 15.8 × 10.1
Mark of Henrik Wigström; gold
mark of 56 zolotniks and silver mark
of 91 zolotniks (1908–17);
FABERGÉ in Cyrillic characters

p. 27 Frame with a photograph
of Queen Alexandra
RCIN 23306
Mark of Michael Perchin; gold mark
of 56 zolotniks (before 1896);
photograph by Alice Hughes

p. 28 Frame with a photograph
of Tsar Alexander III
RCIN 32473
9 × 6.9 × 6.4
Illegible workmaster's mark; Moscow
gold mark of 56 zolotniks and silver
mark of 84 zolotniks (1896–1908);
C. FABERGÉ in Cyrillic characters

p. 29 Frame with a photograph
of Tsarevich Alexis
RCIN 40105
10.2 × 8.4 × 5
Mark of Victor Aarne; silver mark of
88 zolotniks (1896–1908);
FABERGÉ in Cyrillic characters

p. 31 Frame with a miniature
of Tsarina Maria Feodorovna
RCIN 40107
9 × 7.8 × 7.3
Mark of Michael Perchin; gold mark
of 56 zolotniks (before 1896);
FABERGÉ in Cyrillic characters;
miniature signed Zehngraf

p. 31 Column frame with a miniature
of King Christian IX and Queen
Louise of Denmark
RCIN 40097
16 × 5.3 × 5.3

p. 32 Frame with a photograph
of Queen Maud
RCIN 40230
5.5 × 4.7 × 4.7
Mark of Michael Perchin; gold mark
of 56 zolotniks (before 1896);
FABERGÉ in Cyrillic characters

p. 33 Frame with enamelled view
of Sandringham House
RCIN 40492
9 × 15.2 × 7.1
Mark of Henrik Wigström; gold
mark of 56 zolotniks (1896–1908);
FABERGÉ in Cyrillic characters

p. 34 Frame with enamelled view
of Sandringham Church
RCIN 40494
4.7 × 7.8 × 3
Mark of Henrik Wigström; gold
mark of 56 zolotniks

p. 35 Crow
RCIN 13756
7.8 × 15.7 × 5.7
Mark of Henrik Wigström; silver
mark of 88 zolotniks

p. 36 Portrait model of Persimmon
RCIN 32392
24.3 × 31.2 × 9.6
Mark of Henrik Wigström; silver
mark of 91 zolotniks (1908–17);
FABERGÉ in Roman letters; English
import marks for 1908

p. 38 Pig
RCIN 40015
3.5 × 4.7 × 2.1

p. 39 Litter of piglets
RCIN 40038
0.9 × 5.2 × 3.8
Mark of Michael Perchin; gold mark
of 56 zolotniks (1896–1908)

p. 40 Caesar
RCIN 40339
5.9 × 8.4 × 3.3

p. 41 Kiwi
RCIN 40342
5.5 × 5.3 × 4.5
Mark of Henrik Wigström; gold
mark of 72 zolotniks (1908–17)

p. 42 Elephant
RCIN 40044
4.5 × 6.2 × 3

p. 43 Chimpanzee
RCIN 40377
7.5 × 6.2 × 7.6

p. 44 Doe and three baby rabbits
RCIN 40409
4.6 × 8.4 × 6.7

p. 45 Dexter bull
RCIN 40428
8 × 11 × 4

p. 46 Parrot on a perch
RCIN 40481
14.5 × 7.2 × 6.2
Mark of Michael Perchin; silver mark
of 88 zolotniks (1896–1908);
FABERGÉ in Cyrillic characters

p. 47 Seal on an ice floe
RCIN 40264
5.2 × 8.6 × 5.4

p. 47 Queen Alexandra's dormouse
RCIN 40261
6.2 × 5.2 × 5.8

p. 48 Ostrich
RCIN 40277
8.5 × 5.4 × 3.5

p. 49 Lily of the valley
RCIN 40217
14.5 × 7.8 × 5.5

p. 51 Rowan spray
RCIN 40508
22.5 × 20.5 × 7.5

p. 51 Wild cherries
RCIN 40218
13.5 × 9.2 × 4.8

p. 52 Philadelphus
RCIN 40252
14.2 × 7 × 9

p. 53 Pansy
RCIN 40505
10.7 × 5.5 × 4

p. 54 Chrysanthemum
RCIN 40506
24.6 × 11.3 × 7
Mark of Henrik Wigström; gold
mark of 72 zolotniks (1908–17);
FABERGÉ in Cyrillic characters

p. 55 Kovsh
RCIN 32537
17.8 × 28.3 × 13.7
Mark of Julius Rappoport; silver
mark of 84 zolotniks (before 1896);
FABERGÉ in Cyrillic characters

p. 57 Pair of candlesticks
RCIN 32444
21 × 8.8 × 8.5
Mark of Julius Rappoport; silver
mark of 88 zolotniks (before 1896);
FABERGÉ in Cyrillic characters

p. 57 Bell push
RCIN 40124
5.2 × 5.8 × 5.8
Mark of Karl Armfelt; silver mark
of 88 zolotniks (1896–1908);
FABERGÉ in Cyrillic characters

p. 58 Magnifying glass
RCIN 40165
11.4 × 3.8 × 0.9
Mark of Michael Perchin; gold mark
of 56 zolotniks (1896–1908);
FABERGÉ in Cyrillic characters

p. 59 Pear-shaped pot
RCIN 40208
4.8 × 3.5 diameter
Mark of Michael Perchin; gold mark
of 56 zolotniks (1896–1908);
FABERGÉ in Cyrillic characters

p. 59 Seal
RCIN 19409
7.6 × 2.8 diameter
Mark of Michael Perchin; gold mark
of 56 zolotniks (1896–1908);
FABERGÉ in Cyrillic; the matrix
engraved 'Victoria'

p. 60 Vase
RCIN 49821
15.7 × 24.9 × 20.3
Mark of Henrik Wigström; silver
mark of 88 zolotniks (1896–1908);
FABERGÉ in Cyrillic characters

p. 62 Chelsea Pensioner
RCIN 40485
11.2 × 4.5 × 2

p. 63 Bust of Tsar Alexander III
RCIN 40512
17.6 × 7.5 × 5.3

KING GEORGE V AND
QUEEN MARY

p. 70 The Basket of Flowers Egg
RCIN 40098
23 × 10 diameter

p. 72 The Colonnade Egg
RCIN 40084
28 × 17 diameter
Mark of Henrik Wigström, gold
mark of 56 zolotniks (1908–17);
FABERGÉ in Cyrillic characters

p. 74 The Mosaic Egg
RCIN 9022
9.5 × 7 diameter;
surprise 7.9 × 5.5 × 2.9
Engraved C. Fabergé and G. Fabergé

p. 78 Easter egg
RCIN 9032
9.5 × 7 diameter
Mark of Michael Perchin

p. 82 Box with a view of the Kremlin
RCIN 32474
3.1 × 7.9 × 5
Moscow silver mark of 88 zolotniks
(1908–17); FABERGÉ in Cyrillic
characters

p. 83 Box
RCIN 22991
2 × 5.6 × 3.8
Mark of Michael Perchin; gold mark
of 56 zolotniks (1896–1908);
FABERGÉ in Cyrillic characters

p. 84 Cigarette case
RCIN 4320
1.6 × 8.5 × 5.3
Mark of Eduard Schramm; gold
mark of 56 zolotniks (before 1896)

p. 85 Box
RCIN 9163
1.7 × 7.5 × 2.8
Mark of Henrik Wigström, gold
mark of 56 zolotniks (1908–17);
initials of Carl Fabergé in Roman
letters; *FABERGÉ* in Roman letters;
English import marks for 1911

p. 86 Box
RCIN 9314
3.8 × 13.7 × 9.3
Mark of Michael Perchin; gold mark
of 72 zolotniks (before 1896);
FABERGÉ in Cyrillic characters

p. 87 Cigarette case
RCIN 9339
2.2 × 8.4 × 8.5
Mark of Henrik Wigström; gold
mark of 72 zolotniks (1896–1908);
FABERGE in Cyrillic characters

p. 88 Imperial presentation box
RCIN 8999
1.7 × 8.2 × 4.5
Mark of Michael Perchin; gold mark
of 72 zolotniks (before 1896);
FABERGÉ in Cyrillic characters

p. 89 Box with a miniature of
Peter the Great's Monument
RCIN 19126
2 × 9.3 × 6.2
Mark of Henrk Wigström; gold mark
of 56 zolotniks (1908–17);
FABERGÉ in Cyrillic characters

p. 91 Imperial presentation box
RCIN 19128
3.2 × 9.5 × 6.4
Mark of Henrik Wigström; gold
mark of 72 zolotniks (1908–17);
FABERGÉ in Cyrillic characters

p. 93 Bonbonnière
RCIN 40490
2.5 × 5.7 diameter
Mark of Henrik Wigström; gold
mark of 72 zolotniks (1896–1908);
FABERGÉ in Cyrillic characters

p. 94 Box with a view
of Stratford Church
RCIN 40497
2.8 × 6.8 × 7
Mark of Henrik Wigström; gold
mark of 72 zolotniks (1896–1908);
FABERGÉ in Cyrillic characters and
Carl Fabergé's initials in Roman
letters; English import marks for
1911

p. 95 Coronation vase
RCIN 8949
16.5 × 13.5
Mark of Michael Perchin; gold mark
of 72 zolotniks (1896–1908);
FABERGÉ in Cyrillic characters

p. 96 Desk seal
RCIN 9258
6.4 × 2.8
Mark of Michael Perchin; *FABERGÉ*
in Cyrillic characters

p. 98 Cup
RCIN 23090
6.2 × 7.3 × 5.3
Mark of Erik Kollin; gold mark of
56 zolotniks (before 1896)

p. 98 Cup
RCIN 23083
4.6 × 7.6 × 5
Mark of Erik Kollin; gold mark of
56 zolotniks (before 1896)

p. 99 Snuff bottle
RCIN 23841
7.3 × 4.8 × 2.2
Gold mark of 72 zolotniks
(1908–17); *FABERGÉ* in Cyrillic
characters

p. 100 Frame
RCIN 9056
4.1 × 4 × 3.9
Gold mark of 56 zolotniks
(1896–1908); *FABERGÉ* in Cyrillic
characters

p. 101 Frame
RCIN 9187
5.3 × 5.3 × 4.8
Mark of Michael Perchin; gold mark
of 56 zolotniks (before 1896);
FABERGÉ in Cyrillic characters

p. 102 Cameo portrait
RCIN 23314
10.2 × 4.5 × 6
Mark of Henrik Wigström; silver
mark of 88 zolotniks (1908–17);
FABERGÉ in Roman letters; the
cameo signed C.T. 1911

p. 103 Frame
RCIN 23310
7.9 × 4.8 × 3.9
Silver mark of 88 zolotniks
(1896–1908); *FABERGÉ* in Cyrillic
characters

p. 104 Water buffalo
RCIN 40388
5.9 × 8.4 × 3.3

p. 105 Wild boar
RCIN 40260
6.7 × 8.6 × 5

p. 106 Kangaroo and joey
RCIN 40269
8.8 × 9.7 × 3.1

p. 107 Pelican
RCIN 40066
4.8 × 4.2 × 3.2

p. 108 Convolvulus
RCIN 8943
11.1 × 6.5 × 2.5

p. 109 Bleeding heart
RCIN 40502
19 × 15.3 × 6.2

p. 110 Pine tree
RCIN 40186
12.3 × 6.2 × 5.8

p. 111 Miniature writing table
RCIN 9142
Mark of Michael Perchin; gold mark
of 56 zolotniks (1896–1908);
FABERGÉ in Cyrillic characters

p. 112 Miniature grand piano
RCIN 9030
Mark of Michael Perchin; gold
mark of 56 zolotniks (before 1896);
enamelled above the keyboard
C. Fabergé in Roman letters

p. 113 Miniature terrestrial globe
RCIN 40484
10.5 × 6 diameter
Mark of Erik Kollin; gold mark
of 56 zolotniks and silver mark of
88 zolotniks (before 1896);
FABERGÉ in Cyrillic characters

p. 114 Elephant automaton
RCIN 40486
4.8 × 5.1 × 3.2

p. 115 Miniature tea set
RCIN 19514
Box: 2.4 × 6.4 × 6.4;
Silver mark of 84 zolotniks;
FABERGÉ in Cyrillic characters

KING GEORGE VI AND QUEEN ELIZABETH

p. 120 Imperial presentation box
RCIN 100012
3.1 × 8.3 × 8.3
Mark of August Hollming; gold
mark of 56 zolotniks (1896–1908);
FABERGÉ in Cyrillic characters

p. 121 Miniature desk
RCIN 100013
11 × 8.7 × 6.5
Illegible workmaster's mark; gold
mark of 56 zolotniks (1896–1908);
FABERGÉ in Cyrillic characters

p. 122 Cornflowers and buttercups
RCIN 100011
22.3 × 14 × 8

p. 124 Cornflowers and oats
RCIN 100010
18.5 × 12.3 × 8.5

p. 125 Parasol handle
RCIN 100312
5.3 × 7.4 × 2.4
Mark of Feodor Afanassiev; gold
mark of 56 zolotniks (1896–1908)

p. 126 Imperial presentation box
RCIN 100338
2.8 × 9.8 × 6.7
Mark of Henrik Wigström; gold
mark of 72 zolotniks (1908–17)

p. 127 Cigarette case
RCIN 100304
1.7 × 10 × 6.8
Mark of August Hollming; gold
mark of 56 zolotniks (1896–1908)

p. 128 Box
RCIN 100306
1.9 × 5.1 × 4.4
Mark of Feodor Rückert; silver mark
of 88 zolotniks; *C. FABERGÉ* in
Cyrillic characters; STERLING
RUSSIA in Roman letters

p. 128 Kovsh
RCIN 100327
15.5 × 18.7 × 11.4
Mark of Feodor Rückert; Moscow
silver mark of 88 zolotniks
(1908–17); *C. FABERGÉ* in Cyrillic
characters; English import marks
for 1913

p. 130 Desk clock
RCIN 100316
12.8 × 9.2 × 0.7
Mark of Henrik Wigstöm; silver
mark of 88 zolotniks (1896–1908)

p. 130 Frame
RCIN 101531
Height 21
Mark of Anders Nevalainen; silver
mark of 88 zolotniks (1896–1908)

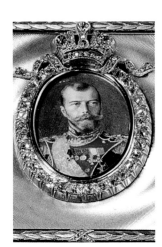

THE QUEEN AND THE DUKE OF EDINBURGH

p. 136 Fan
RCIN 25219
23.7 × 42 × 3.2
Mark of Henrik Wigström; gold
mark of 56 zolotniks (1896–1908)

p. 138 Inkwell
RCIN 49631
8.6 × 17 × 9.5
Mark of Anders Nevalainen; silver
mark of 88 zolotniks (before 1896)

p. 139 Clock
RCIN 95642
10.3 diameter
Mark of Henrik Wigström; silver
mark of 88 zolotniks (1896–1908);
FABERGÉ in Cyrillic characters

p. 140 Woodcock
RCIN 50706
8.6 × 17 × 9.5
Illegible maker's mark; silver mark
of 88 zolotniks (1908–17);
FABERGÉ in Cyrillic characters

p. 141 Clock
RCIN 95643
11.2 × 10.7 × 2.6

p. 142 Clock
RCIN 250167
Height 18.5
Mark of Michael Perchin; gold mark
of 56 zolotniks (1896–1908) and
silver mark of 88 zolotniks

p. 143 Double frame
RCIN 95644
9.5 × 17
Gold mark of 56 zolotniks
(1896–1908); *FABERGÉ* in Cyrillic
characters

THE PRINCE OF WALES

p. 147 Frame
RCIN 100310
12 × 11.4 × 1
Mark of Michael Perchin; gold mark
of 56 zolotniks (before 1896);
FABERGÉ in Cyrillic characters

p. 148 Desk seal
RCIN 100339
9.5 high
Mark of Henrik Wigström

p. 149 Seal
RCIN 95774
5.2 × 2.7
Gold mark of 56 zolotniks
(1908–17)

p. 150 Letter opener
RCIN 95768
31 × 2 × 1.5
Mark of Anders Nevalainen; silver
mark of 84 zolotniks (1896–1908)

Copyright and Acknowledgements

Published by Royal Collection Enterprises Ltd
St James's Palace, London SW1A 1JR

For a complete catalogue of current publications, please write to the address above,
or visit our website at www.royalcollection.org.uk

SKU 013752

ISBN 978 1 905686 37 7

British Library Cataloguing in Publication Data: A catalogue record for this book
is available from the British Library.

Designed by Mick Keates
Production management by Debbie Wayment
Colour reproduction by Altaimage, London
Printed on Gardamat 150gsm
Printed and bound by Graphicom srl, Vicenza

PICTURE CREDITS

All works reproduced are in the Royal Collection unless indicated below.
The Royal Collection is grateful for the permission to reproduce the following:
p. 18, Fersman Mineralogical Museum; p. 53, Courtesy of Ulla Tillander-Godenhielm;
p. 112, Wartski, London; p. 122, Wartski, London; p. 132, © PA Photos.

Every effort has been made to contact copyright holders; any omissions are
inadvertent and will be corrected in future editions if notification of the amended
credit is sent to the publisher in writing.

ACKNOWLEDGEMENTS

The permission of Her Majesty The Queen to reproduce items from
the Royal Collection and the Royal Archives is gratefully acknowledged.

The publication of this book would not have been possible without the support
of colleagues in the Royal Collection and Royal Household. I gratefully acknowledge
the assistance of Jacky Colliss Harvey, Nina Chang, Debbie Wayment and particularly
Mick Keates. Sir Hugh Roberts kindly read the manuscript and made many
useful suggestions. Stephen Chapman and Dominic Brown produced the excellent
photography. I am indebted to the following colleagues for their help with research
and preparation of the objects: Jill Kelsey, Stephen Murray, Lisa Heighway,
Paul Stonell, Katie Holyoak, Stephen Patterson, Jonathan Marsden, Shaun Turner,
Simon Metcalf, Leslie Chappell and Dame Anne Griffiths. I am also indebted
to Kieran McCarthy, Geoffrey Munn, Ulla Tillander-Godenhielm, Alice Milica Ilich
and Tatiana Fabergé for their generous assistance.